HOUSEHOLDS

Households

MARK ROBBINS

Essays by BILL HORRIGAN and JULIE LASKY

THE MONACELLI PRESS

The author and the publisher gratefully acknowledge the generous support of: Graham Foundation for Advanced Studies in the Fine Arts, The Leff Foundation, Radcliffe Institute for Advanced Study

First published in the United States of America in 2006 by The Monacelli Press, Inc.
611 Broadway, New York, New York 10012

Library of Congress Cataloging-in-Publication Data
Robbins, Mark, date.
Households / Mark Robbins;
essays by Bill Horrigan and Julie Lasky.
p. cm.
ISBN 1-58093-164-2
1. Architectural photography.
2. Dwellings—Pictorial works. 3. Robbins, Mark, date.
I. Horrigan, Bill. II. Lasky, Julie. III. Title.
TR659.R58 2006
779'.93923—dc22 2005036820

Printed and bound in China

Designed by Barbara Glauber & Emily Lessard/Heavy Meta

Contents

ACKNOWLEDGMENTS

I UNDERTOOK "HOUSEHOLDS" DURing a fellowship in the visual arts at the Radcliffe Institute for Advanced Study at Harvard University. The importance of that time and studio space cannot be overestimated. I thank the Radcliffe Institute, my colleagues, and the staff and administration, especially Dean Drew Gilpin Faust and Director Judith Vichniac, for their support and encouragement. I am grateful to my friend Beverly McIver for her faith (and her red Volvo) and to Jeanne Jordan, Liz Canner, and Nancy Bauer. Thanks as well to those in the Harvard community who helped make the university and photographic resources available: Bruce Jenkins, Sage Sohier, and Brad Epps. Both Linda Norden, associate curator for contemporary art at Harvard's Fogg Art Museum, and Bill Arning, curator of the List Visual Arts Center at MIT, provided insights into the work in progress. Ivan Rupnik, Joshua Roberts, and Christine Liu, then students at the Harvard Graduate School of Design and Harvard College, assisted with the project. It would have been a very different presentation without their commitment.

Aaron Betsky, director of the Netherlands Architecture Institute, made it possible to expand the project with photography in Holland. Aaron is an able participant in and a supporter of difficult work. Agnes Wijers, coordinator of international projects at the NAI, provided entrée into many of the households and was an excellent guide to the

culture. The Netherlands Consulate-General in New York was also instrumental in bringing me to the Netherlands. Both Jeanne Wikler, general director for cultural affairs, and Robert Kloos, director for visual arts and architecture, were receptive to the idea of creating images of iconic social housing and innovative new work.

The MacDowell Colony provided time to escape professional commitments and work in the company of others. The images of its cabins in this book only begin to suggest the intensity of the work that takes place there. The Acadia Summer Arts Program offered a sylvan setting to work on refining the text.

I am grateful to my friends for their constant presence and ongoing conversation: Kim Ackert, Tory Dent, Stuart Disston, Bill Horrigan, Jude Leblanc, Giuseppe Lignano, Brian McGrath, Gary Morgenroth, and Ali Tayar. Johanna Keller, director of the Goldring Arts Journalism Program at Syracuse University, provided patient editing. Also at Syracuse University, John Mannion at the Robert B. Menschel Media Center took on endless and skillful color calibration and printing. Ann Bremner at the Wexner Center for the Arts has been an incisive editorial guide.

I thank my parents. My mother has an eye for craft and a gift for pointing things out, from biomorphic knockoffs of Swedish art glass to Tudor interiors in Great Neck to the Levitt modern of Roslyn to the framing and cladding of Marcel Breuer's Whitney Museum during its construction. My late father possessed an intellect and subtle yet critical distance from America and popular culture. Two of the compositions in this book are the last series of photographs of my parents together. The politics of both are in this work.

Brett Seamans has supported me and my time away in studios in several states and has watched this project take shape. His presence in my life in so many ways has made this worth doing.

I am thankful to Marco Nocella of the Ronald Feldman Gallery for his interest in this body of work. Helena Reckitt, curator at the Atlanta Contemporary Art Center, was supportive of the 1993 installation "Households + Summer Places." Thanks as well to Ellen Dunham-Jones, director of the architecture program at the Georgia Institute of Technology, for inviting me to Atlanta, and to Frances Hsu and her able teaching assistants, who put the exhibition in place.

Contributors Bill Horrigan and Julie Lasky have brought their perceptive and critical interpretation to the work. Their writing has enhanced the way "Households" can be seen and understood. At The Monacelli Press, I thank editor Andrea Monfried for early support and a precise editorial hand. Elizabeth White provided welcome attention to the production of the book. In her skilled design, Barbara Glauber of Heavy Meta has suggested a subtle reading of the individual pieces and also how they should best be seen as a suite. Nicolas Rojas and Lottchen Shivers have my appreciation for bringing the work a wider audience.

The late Rick Solomon was a wise and evenhanded advocate of numerous projects, including this one. Joan Weakley, executive director at the Bohen Foundation, in a series of conversations shared good ideas about installations and art.

Finally, special thanks to the men, women, and children who welcomed me into their homes and studios: Aaron, Adrian, Agnes, Agymah, Ali, Andrew G., Andrew S., Andy, Anja, Anne, Anthony, Barry, Bill, Bob, Bradley, Brett, Brian, Bruce D., Bruce, Calvin, Casey, Casey J., Charles, Chris H., Chris J., Christopher, Chuck, Con, Dale, Da Shih, David, David C., David G., David M., David P., David S., Diane T., Doug, Drew, Elliot, Els, Erwin, Frans, Gary G., Gary M., Gary S., Giuseppe, Heather, Helen, Henk, Jacob, Jacqueline, James, Jason, Jeanne, Joan, John G., John L., Jonathan, Jonathan C., Joyce, Judy, Julia, Kevin, Kink, Lee, Lenny, Leslie, Lina, Louisa, Lyman, Maria, Marja, Mark, Mark S., Martien, Matthew, Mees, Michael, Michael W., Michael Z., Micki, Miranda, Monty, Nancy, Nikhil, Ouri, Paddy, Paul A., Paul C., Peter G., Peter H., Peter R., Peter S., Pierantonio, Radjinder, Ravi, Rebecca, Reed, Rick, Rodney, Ron, Rosemarie, Rowan, Ryan, Stephen, Steve, Stuart, Sven, Terry, Tom, Tom S., Tony, Vincent, Will, William, Zack, Aunt Irene and Uncle Max, and Mom and Dad.

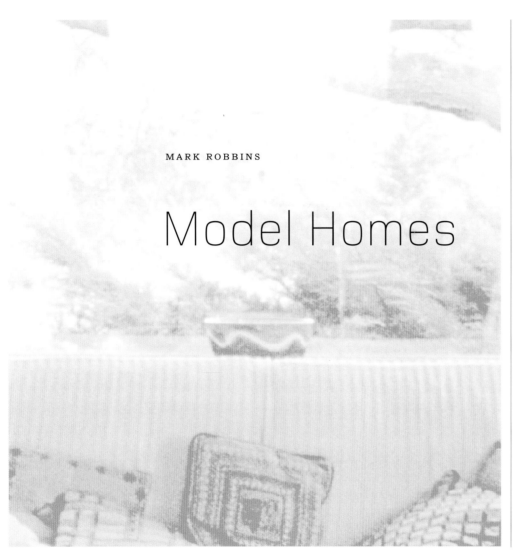

MARK ROBBINS

Model Homes

THE HOUSE ON DUNE ROAD IN Quogue is a simple white Cape Cod that belongs to the family of one of my best friends from graduate school. The garage and side wing make a small courtyard off the kitchen entrance. There are no halls: the two lower bedrooms, where the boys would sleep, connect through the bathroom. Upstairs, where I would rarely venture, are three more rooms for the parents and the girls. Each summer I would find the same copy of *National Geographic* and the same Norman Vincent Peale pamphlet on positive thinking. In the evenings, a teal table shaped like a bellows was set for cocktails—bowls of cheese puffs and Spanish peanuts. We would sit with the adults, who were dressed for dinner and dancing at the Field Club, before they went out.

The house at the Fire Island Pines is a quiet, modern, '70s box with two bedrooms, one per couple, separated by a bath and double-height living room. A deck extends to a screened pavilion next to a fence, which shields the place from the boardwalk and from roving deer, and a stair leads to a sun platform atop the roof. The hosts read and talk, a few cuts of Maria Callas, an easy relaxing weekend. Here, it is the body as much as designer labels or interior decor that represents the individual: the effects of the gym, shaving, piercing, tattooing, sex, steroids, and HIV drug therapies are readily evident. Black oxfords and white quarter socks, snug and revealing t-shirt, hair buzzed too short, all fit.

The rituals at the Pines are as consistent as those in Quogue. I often think about the succession of the residents and the real estate, who will inherit or buy these homes, what type of social life they will step into. On Dune Road, the modest white Cape serves a new generation of the same family. The parents have moved to the back house, and it is the adult offspring, all with children, who run this one. In the Pines, the two halves of the house have changed hands in a succession of friends rather than family.

Ritual and decor, identity and the body: these longstanding interests are at the heart of "Households." The impulse for the project goes back to collegiate forays into sociology and filmmaking in the mid-1970s. After seeing documentary works by Jonas Mekas, I planned to film a girlfriend's parents' apartment in a Necco-Wafer-pastel postwar mid-rise development called Le Havre overlooking the Throgs Neck Bridge in Queens. My friend's inordinately thin mother, in spandex Capri pants, acid blonde flip, and thin ladies' cigarette, would serve us fruit juice and Tab in the white-on-white laminate kitchen. An angelic picture of her daughter playing the piano as a child sat atop the very same grand piano, which sank in a field of high, white pile carpet.

In fact, I was always interested in the way other people lived: Whose mothers served grilled cheese sandwiches rather than rice pilafs and who lived in Tudor revival houses rather than

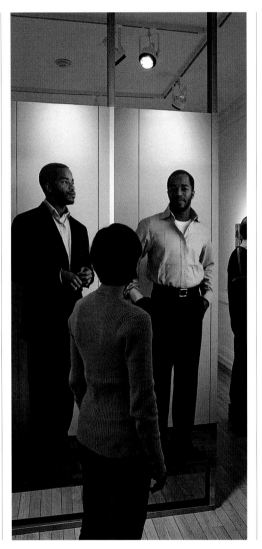

Mark Robbins, "Households," Radcliffe Institute, Harvard University, Cambridge, Massachusetts, 2003.

in small apartments with elevators an hallways that smelled of cooking? Who sat down to dinner at heavy reproduction Spanish tables facing Long Island Sound and who at Formica dinette sets with a view of the street through a small bay window? Interior decor and collections of objects, rather than a sophisticated use of space, display wealth and erudition. My own adolescent template for how the rest of the world lived was informed by visions of home that ranged from the high style of 1930s MGM to the gingham domesticity of Lassie's Americana. (I looked and spoke no more like Timmy than my mother did June Lockhart, which perhaps accounted for the trenchant allure of both.)

The correspondence of decor and character was not limited to family and friends. Model homes and furniture-stores displays attempted to produce a coherent vision of taste and style to lure buyers. In the years after architecture school, my friends, mostly young architects, lived in apartments that looked nothing like the iconic rooms we studied or designed for others—but I imagined *House & Garden* layouts, fully propped and framed, on Avenue B or in Hell's Kitchen.

Years later, Columbus, Ohio, provided new territory for a series of collages that intercut fragments of decor and space drawn from inside other people's homes. In contrast to Hollywood's mod "pads" or the Victorian interiors of style magazines, these were unvarnished and homemade;

but they did draw from a similar canon of references. A Spanish ambulatory around a Naugahyde dinette set in a suburban ranch, reproduction Tiffany lamps and oversize Stickley pieces crowded into a low-ceilinged worker's cottage, crown moldings and shirred fabric mixed with Bombay Company and IKEA in a postwar apartment: I was interested in the aspirations that these interiors expressed and what those aspirations represented.

The images in "Households" reflect the ways in which we make places and fashion ourselves. The subjects are friends, relatives, acquaintances, friends of friends, and so on. They range in spousal status, age, and occupation (architects, writers, doctors, minister, window-dresser, hairdresser, Shriner/insurance salesman, supermarket food tester, and dancer/videographer). I was drawn to men and women in my own generation and younger people and also to older couples like my parents and my aunt and uncle, who have made several homes and produced families over a number of decades. The photographic compositions offer various class and family types as well as set-

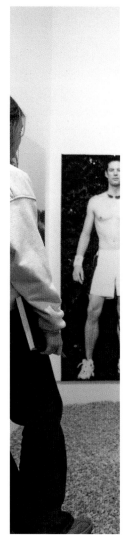

tings, architectural and natural, that suggest narratives about "lifestyle," multiple visions of the domestic. The individuals, couples, and groups are documented straight: *National Geographic* but chez nous.

The groupings recall older forms of portraiture, from the trompe l'oeil images, paneled walls, and life-size figures in Pompeian courtyards—like Villa dei Misteri—to the flanking saints of Flemish altarpieces, from Giulio Romano's fresco giants to Vermeer's great women. The subjects in "Households," like those figures, are posed with their belongings and in their environments. The images record a person at a particular moment, with decor, fashion, and furnishings, often with a view to the outside world.

The work was influenced by visual art of the 1970s that combined a pop fascination with the American vernacular and an implied social critique, such as Dan Graham's images of American subdivisions. Tina Barney's crisp family portraits still resonate, as do David Hockney's representations of the landscapes and bodies of Los Angeles, Lynne Cohen's images of anonymous uninhabited spaces, and John

Baldessari's multipaneled, rebuslike paintings.

"Households" is also set against the current popular fascination with the interior as a form of self-improvement and therapy. Domestic harmony, perfect romance, and great wealth are within reach in the profusion of television reality shows, both those explicitly dedicated to decor ("Trading Spaces") and those that simply provide fantasy settings ("The Bachelor" and "The Apprentice"). These shows offer primers for social and economic success but also a vision of the setting for that success. They are as zealously instructive as infomercials and morality plays.

The homes in "Households" are apartments, cottages, mansions, log cabins, and even a re-used storage tank. Some of the spaces are rented, others owned, others borrowed. The houses and apartments mirror in varying degrees the attention to the body and to fashion of the residents. In both content and format, these images borrow from the soft-core glossiness of fitness and home magazines, the buoyant comfort of Gap ads and J. Crew catalogs. Ultimately I am interested in the way we align ourselves—and are aligned—in relation to each other and to the market culture, notably in advertising and media. The body of images illustrates a complex view of families and the American "homeland."

The photographs of "Households" incorporate several series taken over a three-year period. The first, begun at the Radcliffe Institute for

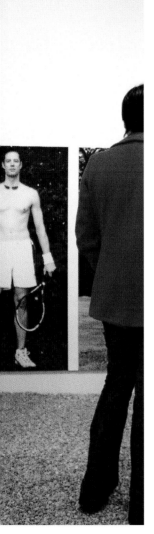

Advanced Study in 2002, presents couples and individuals, mainly gay men, in cities in the North and Southeast. These first portraits both undercut and confirm stereotypes about interiors, taste, and body type.

The more recent series on vacation homes shows transitory rather than permanent attachments. In summer and holiday areas, people move in and move out; they may decorate for themselves or may live among furnishings selected by others. Some of these vacation communities, both gay and straight, share a relative homogeneity in terms of style, class, and race. Both the Pines and Quogue, for example, offer, in broad terms, a time capsule of dress and decor. In many of these images, the landscape is as important as the interior in suggesting the life of the occupants.

Institutional homes are a subset of these temporary accommodations. Residences, often historic, owned by universities and other establishments are occupied ex officio by contemporary residents. Here the underpinnings of the space are fixed; yet the furnishings of the current inhabitant can merge with or overtake the interior. The cottages of the artist's colony, set in pine forests and fields, are still another iteration of the vacation house. These are lived in only for brief periods; the interiors are filled with artists' supplies, computers, and a few portable arti-

facts from home. Writing desks, pianos, sculpting winches, and easels, along with mismatched furniture, Adirondack night tables, and day beds, are provided by the colony.

The latest series is on housing in the Netherlands, principally in Rotterdam and Amsterdam. Housing is said to be the basic building block of the Dutch city. The subjects in this series live in the iconic modern apartments of architects such as J. J. P. Oud and M. Brinkman. These interiors are known, for the most part, through grainy black-and-white record shots of unoccupied "Existenzminimum" rooms. Eighty years later, the facades have been preserved while many of the interiors have been reconfigured. The photographs also document the continuing public commitment in the Netherlands to the social project of housing, evident in the apartment houses by contemporary architects on Java Island and other recently reclaimed docklands.

"Households" presents individuals and families, apartments and houses, city views and rural vistas. During the course of the project, couples have moved and split up, singles have become couples, individuals continue to live with illnesses, houses have changed, and properties have changed hands. The collection itself is a hedge on the present and marks time. The photographs show settings in which continuity and an illusive permanence can be read, in which aging and succession—of generations, rituals, and styles—take place.

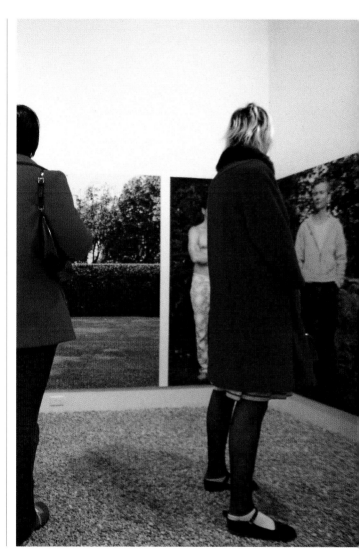

JULIE LASKY

Exposure Time: Posing the Home

WE ARE WHERE WE LIVE. THIS is not a reference to location but a statement about identity—a message that dates from the nineteenth century yet never gets old. It is trumpeted with fanfare by shelter magazines, big-box stores, reality TV programs, and e-commerce sites. "Thousands of ways to make your home more YOU!" boasts the cover of a recent IKEA catalog, a publication whose magazinelike format, complete with headlines, signals not only the correspondence between self and domicile but also the increasingly blurry boundaries between showing and selling. The tagline of the popular magazine *Real Simple* is "Life/Home/Body/Soul," the words separated by slashes to stress their equality.[1]

Indeed, more and more magazines are collapsing themes of self- and home improvement in order to provide instruction manuals for living. *Martha Stewart Living* and *Budget Living* are two periodicals that bare that objective in their titles. And with a growing number of retail channels hawking affordable goods to a global market, the promise of continual self-invention through home design multiplies. The dream on offer is one of a perpetual adolescence with the license to live as anything—austere, morose, sociable, glamorous, high-tech, tweedy, or Moroccan—and commit to nothing. Rustics can shop for faux-antique farm tables at ABC Carpet & Home in Manhattan or scour eBay for authentically gouged furniture.

1. One might argue that, typographically at least, *Real Simple*'s themes are not emphasized equally: "life" and "body" are set in boldface in the tagline, whereas "home" and "soul" appear in a regular type weight.

Postmodernists can ferret out Michael Graves's florid, colorful products for Target or await the return of Memphis, the 1980s Italian design movement overdue for a revival (along with the rest of that dormant decade's aesthetic adventures).

Yet the connection between home and personal identity is too ingrained to be limited to adolescent aspiration. It also belongs to more mature frames of mind. In the August 2005 issue of *House & Garden*, editor Dominique Browning writes of her reluctance to fix a dilapidated summer home because she identifies with its condition: "The problem is I don't want to renovate the house," she laments. "I love it exactly the way it is. I know I shouldn't; this is an immature, fantastical sort of relationship in which I project onto a building my own feelings of being oddly constructed, quietly cantankerous, hard to figure out, and on the downhill slope of physical well-being."[2]

Browning's empathy with her property is far from unique to our age. In *Sex and Real Estate: Why We Love Houses*, Marjorie Garber dates the idea of conveying personality through decor to the late nineteenth century, when mass-produced goods became affordable enough to supply the middle class with an ample palette for expression. By the early twentieth century, tastemakers such as the interior designer Elsie de Wolfe and the etiquette maven Emily Post were instructing women to think of their domiciles as extensions of themselves. Garber quotes de

Wolfe's admonition of 1913: "A house is a dead-give-away, anyhow, so you should arrange it so that the person who sees your personality in it will be reassured, not disconcerted."[3]

As the quantities of affordable merchandise soared in the late nineteenth century, so too did the number of publications educating Victorians about how to furnish their homes. The scenario was much like today's, with presses pumping out shelter magazines and factories pumping out cheap goods. Aimed at women, who took a larger role in managing household affairs as the century progressed, the magazines were true to the era's moralistic tenor in that they began as guides to good conduct. Gradually, however, they shifted their focus to decor—which is not to say they lost their ethical dimension. For the Victorians, even interior design was freighted with moral significance. Consider the skirts that clothed bare piano legs—"limbs," as they were delicately called.

With goods and guidance, a woman now had the means to design a home in her own image, but none of this could have been achieved without photography. The development in the 1880s and 1890s of smaller cameras that required shorter exposure times (thanks to electric interior lighting) let homeowners document their design accomplishments. Further, with the introduction of halftone reproduction technology in the early 1880s, images were more easily printed in magazines, spreading decorating ideas to a receptive

market. As photography opened the Victorian home to wider inspection, the personae encapsulated within its four walls assumed a more deliberate public face. This breach of the threshold between private and social realms helps to account for decorative arts historian Cheryl Robertson's observation of a growing "professionalism" in attitudes toward home design in the 1880s and 1890s. At that time, Robertson notes, "Women's magazines and trade literature directed to a female audience had begun to substitute the term *homemaking* for *housekeeping*. The shift in vocabulary bespoke a reordering of domesticity from a passive, custodial duty to an active, creative vocation that involved the same decision-making and coordinating talents demanded of office managers and entrepreneurs."[4]

The distinction between house and home—and the very question of what constitutes a household in today's society—is fundamental to Mark Robbins's "Households." In this collection of portraits, the sitters are sometimes sitting rooms (or kitchens or bedrooms) and the people are polished, draped, and arrayed like furniture. The word "household" suggests at least several inhabitants, yet many of this book's subjects live alone, many are same-sex couples, and only a few are represented as families. In Robbins's assemblages—composed in formats resembling architectural plans or elevations, or in some cases the triptychs of medieval altarpieces—home dwellers

2. Dominique Browning, "Renovation Blues," *House & Garden*, August 2005, 2.

3. Quoted in Marjorie Garber, *Sex and Real Estate: Why We Love Houses* (New York: Pantheon Books, 2000), 95.

4. Cheryl Robertson, "From Cult to Profession: Domestic Women in Search of Equality," in *The Material Culture of Gender, the Gender of Material Culture*, eds. Katherine Martinez and Kenneth L. Ames (Winterthur, Del.: Henry Francis du Pont Winterthur Museum, 1997), 84–85.

occupy their own tightly cropped columnar spaces surrounded by other images showing shreds of their environments. Slim margins separate the people from their interiors, building facades, urban settings, and one another—even when they are shown side by side.

Is that discrete white border a margin of

One way Robbins accomplishes this is by testing our perceptions of public and private. His camera makes conspicuous forays into intimate life: conjugal beds and bathrooms are on display; many individuals are nude or partially undressed. Yet formally posed, facing the camera, the subjects are hardly caught unawares. The body, like

cannot dispel the sense of artifice—many of the bodies are obvious products of exercise regimes, and people are shoeless or shirtless in ways that suggest a compromise with the photographer rather than a habitual mode of comfort. And yet, when a camera is invited into the home, it represents not only how the subjects would like to

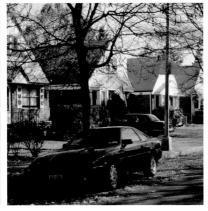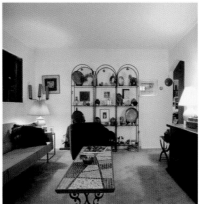

appear but also who they are when the rest of the world isn't looking—their rituals, vices, and negotiations with lovers and family members.

Flashes of flesh are revealing, but what they illuminate extends beyond physique or decor. For example, in "American Philosophy," Robbins's portrait of two college professors in a five-year relationship, a marked difference in levels of self-consciousness suggests other tensions. The subjects, posed outside Nancy's shingled New England cottage, flank the interior like pendants in an altarpiece. Nancy wears a zippered jacket, but not for warmth, apparently, because her toes are bare. She looks nervously at the camera from under a curtain of hair, her hands folded protectively over her stomach. Mark is shirtless and gazes off to the side. The verdant setting, her shame, and his skin, not to

privacy? A form of containment? A strip of mortar gluing together the bricks that form an establishment? By atomizing and rebuilding his pictorial edifices, Robbins deconstructs the identities and relationships they represent. House, a rigid carapace, and home, a dynamic constellation of values and tastes, are recombined with a decorator's attention to pattern and symmetry. The result is a paradox: these stable-seeming assemblages end up as portraits of instability, raising many more mysteries about their subjects than they solve.

the home, is prepared for scrutiny. Clothed and unclothed models alike have the anxious, self-conscious, or forced-insouciant expressions of people awaiting judgment.

As in a Victorian parlor, formality is a buffer between real privacy and the world. Even nudity

Mark Robbins, "Mom and Dad, Queens, New York," 2003

14

mention the composition's medieval echoes, connect this image to the Fall. In place of a serpent disrupting Edenic harmony, however, is a living room revealing polarized tastes. Austere Mission-style furniture and a sisal rug cohabit with an Art Deco wing chair and pleated, swagged draperies. Does this photo of clashing yet integrated styles unite the couple or push them apart? Does Mark look at Nancy in complicity, his gaze cutting through the central image, or does he look away from the lens, self-absorbed? The photographer creates the mystery.

Robbins's placement of images is suggestive in many ways. His compositional houses sometimes reflect the organization of real ones (an arrangement that, as children recognize, is anthropomorphic, with upper windows taking the place of eyes, kitchens of bellies, and basements of bowels). In a portrait of his own parents at home, Robbins put the cellar at the bottom of the montage, details of gables at the top, and the living room and kitchen in the middle. But where many homes grow more chaotic on the lower floors, this one demonstrates a fight against entropy at every level. Even with its raw pipes and wires, the basement is a model of rationality.

Robbins also exploits classical symmetry as a feature of both photos and layouts. Typical is "ABA," his portrait of Jonathan and Christopher in their summer home. A bedroom ceiling fan marks the midpoint of the suite. Extending outward on either side are pairs of pillows, windows, and end tables. Next comes a pair of Christopher pictures, then a pair of garden-hedge pictures, and finally a pair of Jonathan pictures. Yet the symmetry is disrupted in both obvious and subtle ways. Christopher holds his tennis racket in two different positions, suggesting a narrative sequence or even a filmstrip. The hedges, however, are identical; they create a strong horizontal directionality that contrasts with the vertical poses. (Such rhythms, reminiscent of the syncopated patterns of building facades, run throughout *Households*.) The portraits of Jonathan are also identical, but one is flopped to form a mirror image. Whereas his partner is animated, his own stance is static, at the periphery.

In the "Households" images, flesh, bone, brick, stone, contoured torsos, and varnished chairs assume equal status. Matching furniture pieces resemble old couples that dress alike. Family members rhythmically posed in doorways take on the formality of caryatids carved into a building's facade. In the interiors, Robbins reveals a particular interest in collections. A wall is arrayed with ethnic masks in one image; shelves are stuffed with political memorabilia in another. These groupings evidence a concentrated form of the homeowner's effort to project identity—a quest to complete and thereby perfect a representation of the self. "Because a collection results from purposeful acquisition and retention, it announces identity with far greater clarity and certainty than other owned objects," note business academicians Russell W. Belk and Melanie Wallendorf.[5] Yet these microcosms of self-definition are also fragments of roomscapes that are in turn assimilated into the larger structure of Robbins's compositions. The viewer is continually reminded that all this cultivation of objects and arrangements is devoted to public perception, mediated through Robbins's lens. Even the most ardent efforts to control appearances slip away from the collector and collide with the photographer's view. Through the very gesture of assemblage, Robbins presents himself not as casual observer of people's homes and lives but as equal partner in the art of contrivance. By the end of *Households*, the question becomes, whose collection is this anyway?

Like any collector, Robbins is driven to encapsulate—but with boundaries that are rewardingly open-ended. Constructed of beamlike panoramas and columnlike figures, his photos represent an edifice that is also anatomy, a bionic merger of nature and art. The skeletal rigor of architecture combined with the emotional nuances of decor mirrors the duality of body and mind. Ultimately, these households register stability and flexibility, an expression of coherence and an erasable slate, a window for voyeurs and a mirror for self-reflection. Even the most modest among them is a mansion with many rooms.

5. Russell W. Belk and Melanie Wallendorf, "Of Mice and Men: Gender Identity in Collecting," in Martinez and Ames, *Material Culture of Gender*, 8.

BILL HORRIGAN

Villas and Cottages

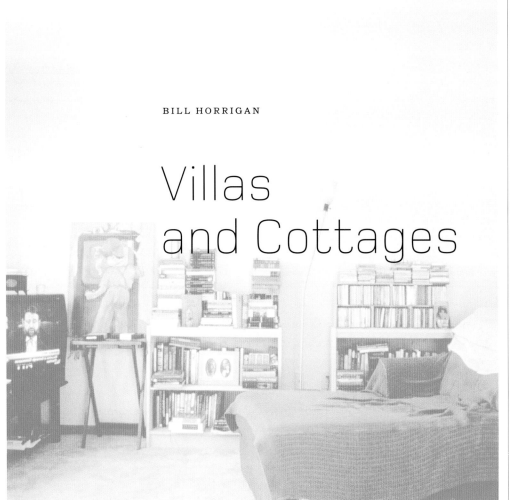

We are not permitted to choose the frame of our destiny. But what we put into it is ours.

—DAG HAMMARSKJÖLD, 1950

I LIVED FOR SOME TIME IN A HOUSE with a front porch shared with Mark Robbins, who lived, when he was there (and not in Rome, or Japan, or Australia, or Washington, D.C., or Manhattan; and when I was not in Brussels), in the house's southern half. Dating from Columbus, Ohio's late nineteenth century, the building had devolved into a boarding house in the neighborhood's unhappy, graceless middle age; it then was rehabilitated into its original form as a two-family dwelling with a shared wall, two three-story living units generally identical in spatial terms. Mark co-owned the house and I was a renter, as in temperament I remain.

Over those years, which ran alongside the entirety of the Clinton administration and then a couple of years into its dismaying successor, I spent what might be considered (or maybe not) an eccentrically copious amount of time sitting on the front porch, a partially covered but otherwise unenclosed slab of concrete a few steps higher than the shawl-sized front yard. I would read the morning papers while sitting on the porch, and talk on the precellular cordless phone there, and read novels there, listen to the radio, and write, and visit, when friends came by, and watch people walking to the Civil War–era park

just around the corner. I had parties on the porch, and twice heard there from friends that they were HIV positive.

I used to think the reason I found myself on the porch more often than I'd observe other people on theirs (the vigilant gentrifying yuppies across the alley; the Greek candy magnate, who despised us, in his self-designed "casa" next door; the disability-dependent desperate cases across the street) was that it was the laziest way for me to enjoy direct sunlight while at home. But that wasn't true or sufficient, because by an hour before noon, season in and out, the sun had pretty much been lost and still I would perch there mornings, afternoons, and evenings. Imagine it as the Marguerite Duras remake of *Groundhog Day: Des journées entières dans les arbres...*(or in this case, *sur la terrasse*). Having since moved

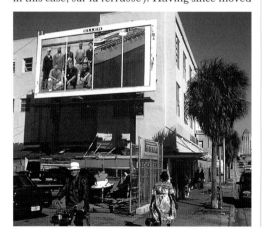

into another rented house with a porch on which in the past three years I have sat exactly never, and today pondering moving again, I now think the porch at Mark's house gave me a literal way out from my failure at being able to imagine, create, and inhabit any coherent domestic interior of my own.

I probably wouldn't have felt this, or decided to conceptualize it as "failure" with such alacritous conviction, had it not been for the odd anxiety that comes from sharing a living space with an architect. Granted, we shared only the porch and the common wall; and despite being professional colleagues intermittently and having a few of the same friends, we pursued separate lives. But I was rarely unmindful that behind our shared wall was a duplicate of my living space within which Mark had managed to produce something legibly and accommodatingly homelike, and my apartment never seemed like anything other than the semiotically evasive way station of a displaced person—all folding card tables, unhung pictures and unshelved books, convenience store stemware, and extension cords.

The extreme contrast, funny except when it wasn't (and the sitcom modality of Jewish versus Catholic gets nowhere near its irregular heart), in how two middle-aged men would choose to furnish and inhabit mirror-image living spaces was much with me in those years, partly because the blunt visual evidence of it was also much with me

(Mark kept an open-curtain policy and there I was on that porch), but equally because he and I, when we talked, would often find ourselves talking about such issues, which touched on fundamental preoccupations of his artistic practice then no less than now—formal and stylistic preoccupations, certainly, but also inevitably an engagement with ideas of class, taste, and sexuality, and with the political implications of that practice and those engagements. Those preoccupations, differently configured and weighted, happened to engage me as well, less in terms of design and architecture (in which I had no training other than hav-

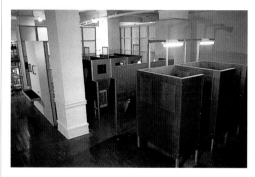

ing been raised sighted in Chicago, where having violent opinions on architecture was wrapped in the parcel of good Democratic citizenship) than in relation to various film and video practices.

Professing "an enduring fascination with other people's lives and houses," Mark Robbins began by insinuating fragments of other people's lives into sculptural apparatuses he would build

precisely to accept them. In his early gallery-based installations, which I first encountered around 1992, Robbins would often include photographic representations of the human figure, still or moving, as an expressive element within a larger architectural effect, introducing photo portraiture to a three-dimensional construction of his own devising. The pieces in which he folded

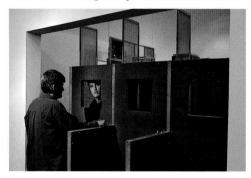

a sculptural construction around video imagery in particular felt aligned with a cinematic imaginary as much as with an architectural one ("Framing American Cities," 1990–92). For Robbins, video and photo portraiture within his installations extended his will both to gaze and eavesdrop on the human subject and also to anchor his exploded, speculative built forms relative to the scale of the figure.

Here, in this book of households, that apparatus is dismantled and consigned to redundancy. There is no sculptural-architectural installation punctuated with fragmentary glimpses of the figure; in its place is, in essence, a family photo album reworked into a series of frozen, undone films. Medium and long shots prevail as each household is given its own sequence, filmwise, on the page; sometimes these are shot/counter-shot, sometimes more extended minimontages. Through willful sequencing, Robbins releases his human subjects from the constraints of his own idealizing built spaces and views them from the inside. In doing that he also finds himself—himself!—inside with them.

Well, inside up to a point. The flattery implicit in being asked to pose for a portrait is usually clouded (for non-narcissists) by an anxiety concerning the end result of being seen. It appears that the people in the households were no strangers to the game of image/risk management, not because Mark Robbins could have been suspected as a cunningly adversarial archivist (on the contrary, the untendentious bedrock of his enterprise is a compound of acquaintanceship, affinity, and curiosity) but because they were consenting to allow the visual residue of their own living and breathing spaces to be exposed to the available light of his Nikon—to surrender the invisibility a hand-wrought or store-bought *mise-en-scène* had up until then enjoyed by virtue of existing behind closed doors. (The non-non-narcissists have no such qualms, and just get on with it.)

A number of his sitters go affably beyond the gesture of flinging open the front door, consenting, or volunteering, to shed the final frontier of clothing in a disarmingly efficient double exposure. In these convergences of the house-proud and the body-proud, some viewers will idle in speculation concerning the back stories of the individuals depicted, as they might do less purposefully with the clothed individuals. Yet as Hannah Arendt once observed, neither vanity nor the need for adoration ranks among the mortal sins, and so the mainly fit and mainly young naked men seen here are less likely to be called to judgment for excesses of pride than for errancy of decor...but not by Robbins. One hundred and fifty years ago in his *Villas and Cottages*, Calvert Vaux prefigured some of Robbins's intuitions, albeit casting them in a virile Emersonian vein:

The lack of taste perceptible all over the country in small buildings is a decided bar to healthy social enjoyments; it is a weakness that affects the whole bone and muscle of the body politic; and it is a needless inconsistency, for a full exercise of freedom of speech and action should naturally result in a full, free exercise of the innocent enjoyment that unfettered industry renders possible, and a refined propriety and simple, inexpensive grace ought habitually to be the distinctive marks of every habitation in which a free American dwells.

As Robbins arrays them on the page, in diptych, triptych, and more elaborately extended sequential and cruciform patterns, the photos

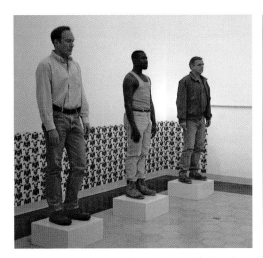

suggest altarpieces and sacramental imprints, shrines to domestic equilibrium and repose. That said, there is a confoundingly unmotivated correlation between the presumed identity of many of the individuals (tracked across viewers' assumptions of class and sexuality) and the iconographic information inscribed in their surroundings. An abiding curiosity of the "Households" photographs is that only occasionally can a causal relationship between the people depicted and the interiors and exteriors they are tied to be advanced with any certainty. If the original photos had been scattered to the floor by a rogue wind, I can't for the life of me imagine that anyone other than Robbins would be able to put the individuals back alongside the settings that are theirs and theirs alone.

Mark Robbins, "Of Mies and Men," American Academy in Rome, Rome, Italy, 1997.

The contract Robbins made with these households, everyone his or her own monarch or saint, allowed the sitters (who are, however, seen full-length, head to toe, the post-Astaire photographer armed with tact enough to keep each person's feet planted in the frame) to select against which objects and interiors they would like to be posed, each sitter thereby colluding with the photographer in the guileful tasks of art direction and scenic design (not to mention the exhausting

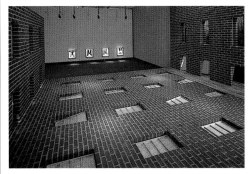

presession demands of wardrobe and makeup). Each sitter was also, knowingly or not, made a member of one of the subcultures destined, for purposes of this volume, for cohabitation: American residents of artists' colonies; *célibataires*; architects, designers, and artists (and enabling curators); same-sex domestic partnerships; nuclear families in Dutch social housing; Robbins's own family and friends...and friends of friends of the above.

Naturally, typage pursued via portraiture re-

Mark Robbins, "Borrowed Landscapes: 36 Views," Museum of Modern Art, Saitama, Japan, 1994.

mains one of photo history's least resistible byways despite its ultimately controvertible, self-fulfilling dynamic; and despite invoking a controlled number of specific groupings as an organizing principle, Mark Robbins seems less intent on producing some visual variations on social types than on piercing the walls of people in his orbit, making public what it looks like on the private side. He hopes neither to validate nor to explode assumptions explaining identity via decor but to revel in the proof of aspiration as that proof is embedded in the array of physical terms contributing to each person's sheltering resort. As democrats, we must turn away from the show of someone else's naked aspirations while, gaze averted, we fiercely chase our own, but "Households" has the decency to give the lie to our own uneven, virtue-driven modesty (is virtue the force? is modesty the goal?) about all that.

They were visibly shy; they stood there letting me take them in—which, as I afterwards perceived, was the most practical thing they could have done.

—HENRY JAMES, *THE REAL THING*, 1893

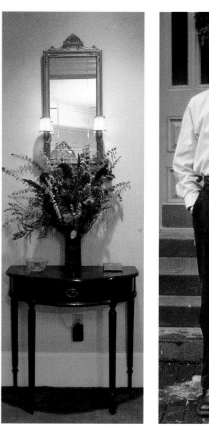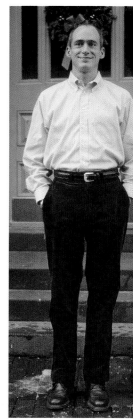

David, 45, Bradley, 44, 5 years
BOSTON, 2002

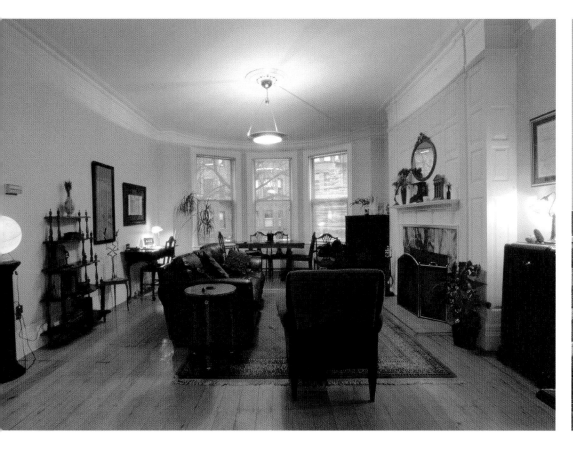

Casey, 36, Reed, 42, 4½ years

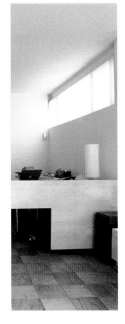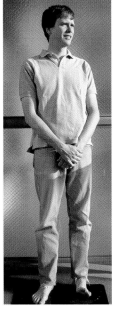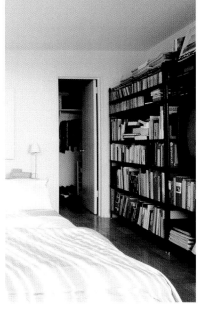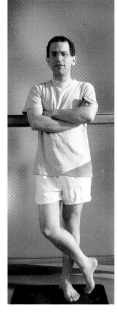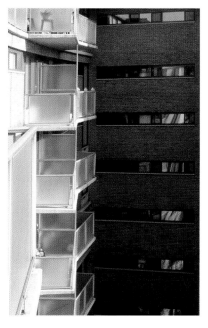

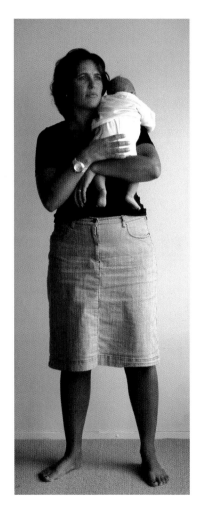
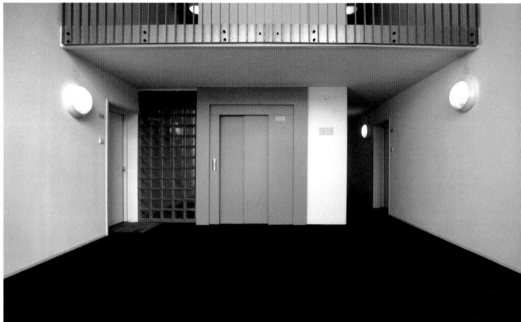
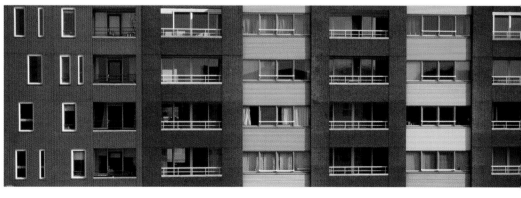

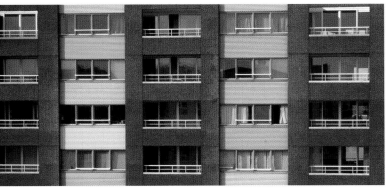

Martien and Julia
AMSTERDAM, 2004
(BUILDING ARCHITECT: SJOERD SOETERS, 1999)

 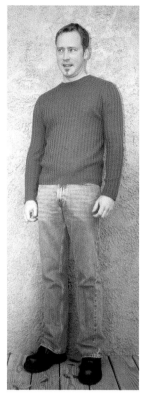 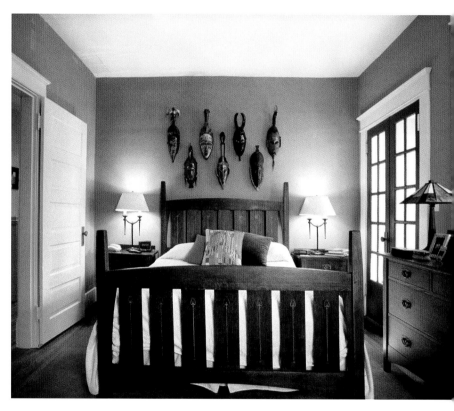

David, 38, Michael, 37
NASHVILLE, TENNESSEE, 2002

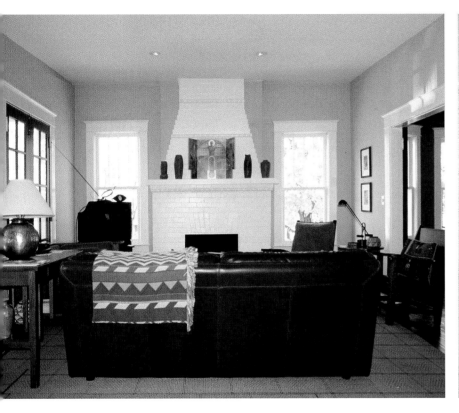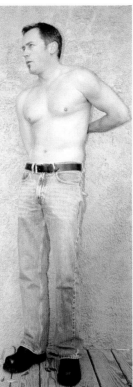

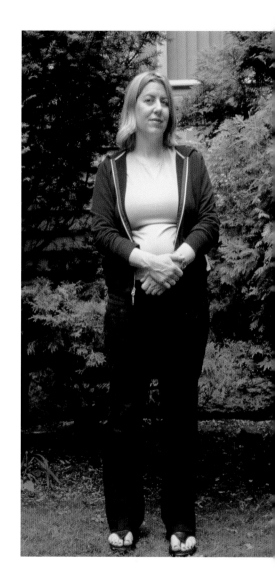

American Philosophy: Nancy, 42, Mark, 51, 5 years
NEWTON HIGHLANDS, MASSACHUSETTS, 2003

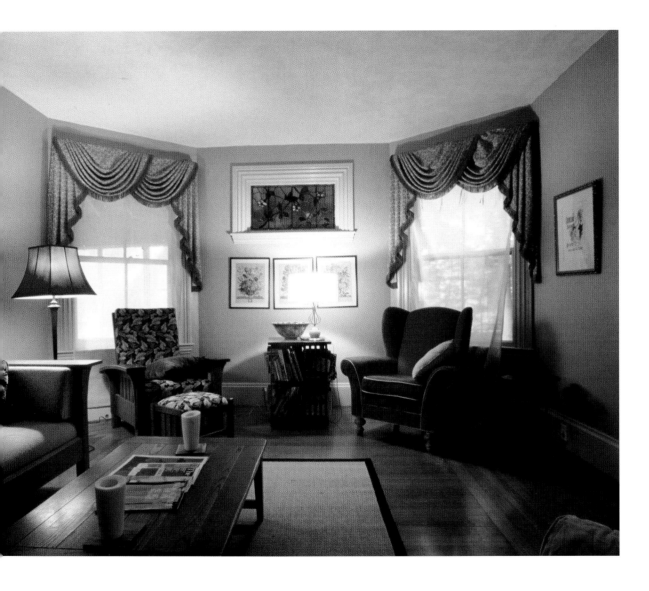

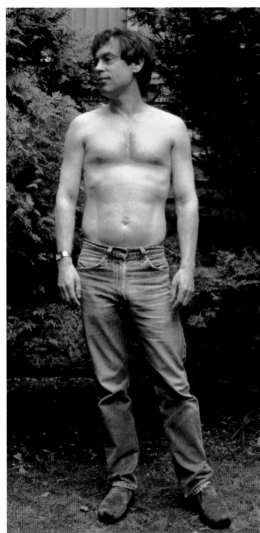

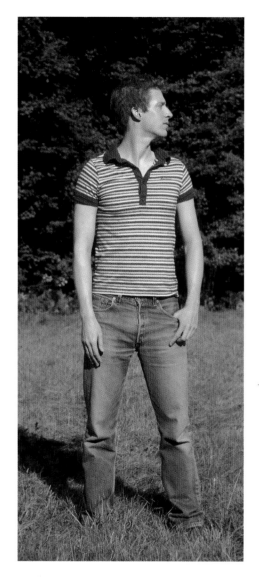

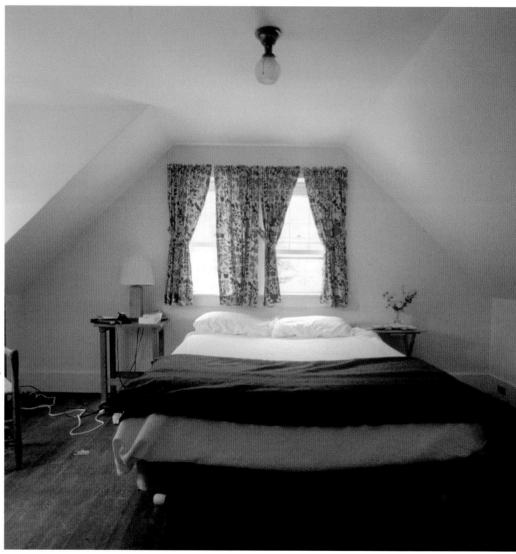

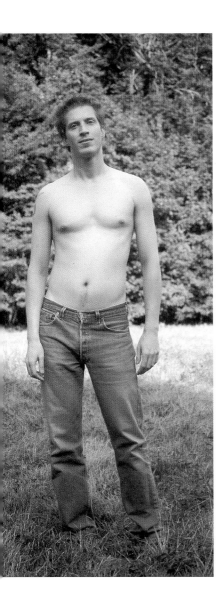

Andy, 28

HEYWARD STUDIO, MACDOWELL COLONY, PETERBOROUGH,
NEW HAMPSHIRE, 2003

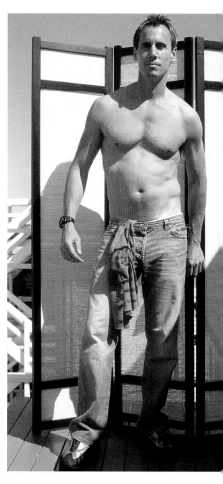

Will, 44

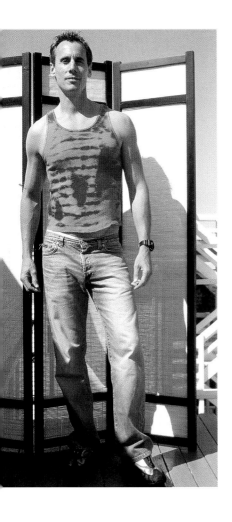

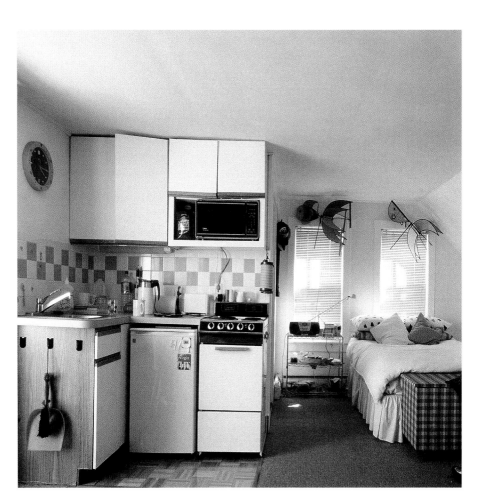

 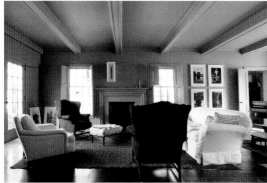

Country: Anthony, 42, Pierantonio, 41, 17 years
AMAGANSETT, NEW YORK, 2003

Anthony, 41, Pierantonio, 40, 16 years
NEW YORK CITY, 2002

Giuseppe, 39, Jonathan, 35, 10 years
NEW YORK CITY, 2002

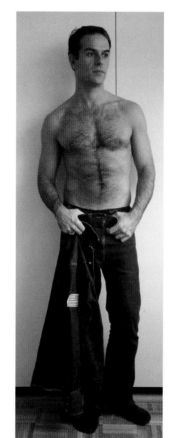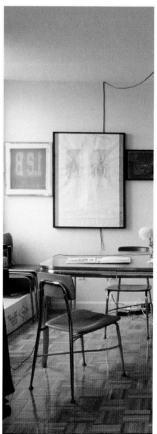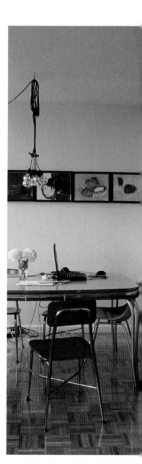

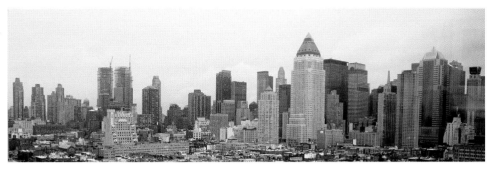

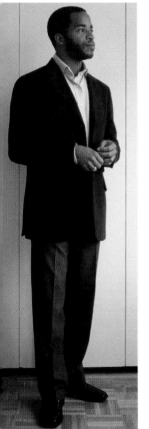
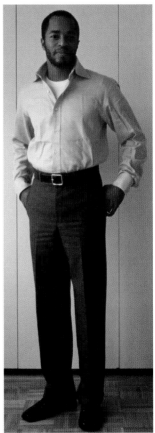
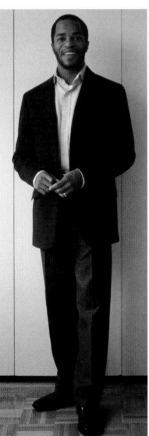

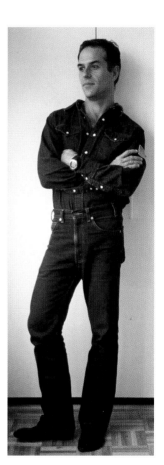

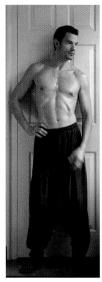
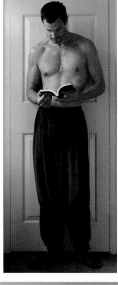
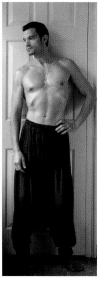

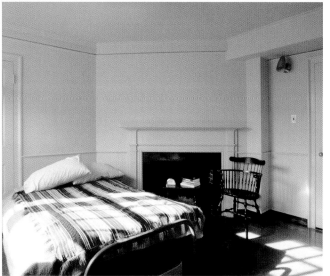

Writer: Kevin, 42
CAMBRIDGE, MASSACHUSETTS, 2002

Nikhil, 37

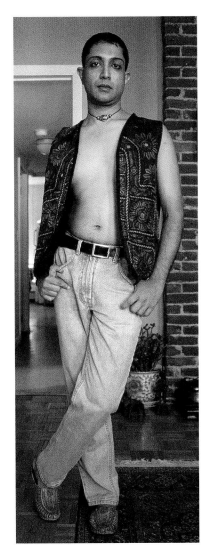

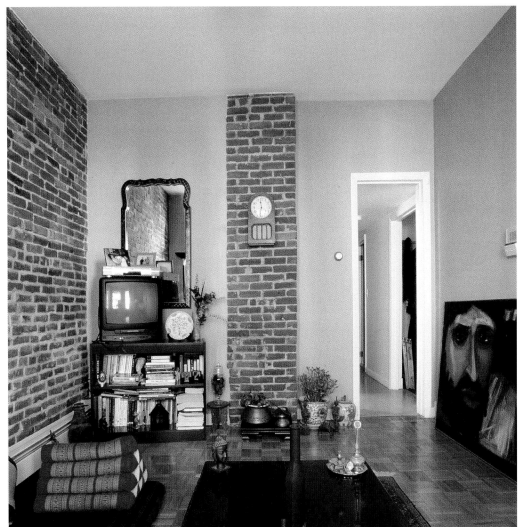

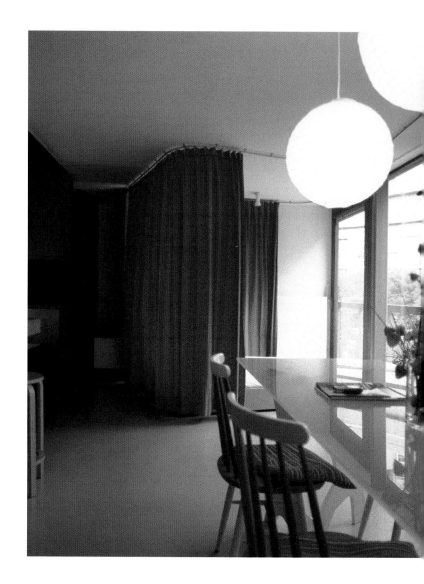

Architect: Paddy

AMSTERDAM, 2004
(BUILDING ARCHITECT: DE ARCHITECTENGROEP, 1999–2000)

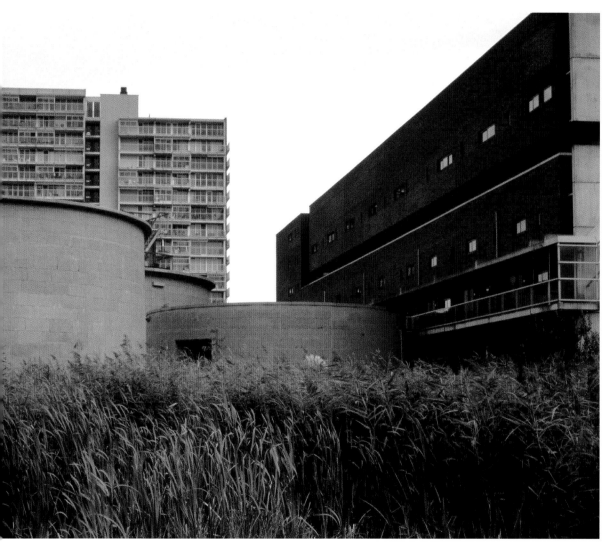

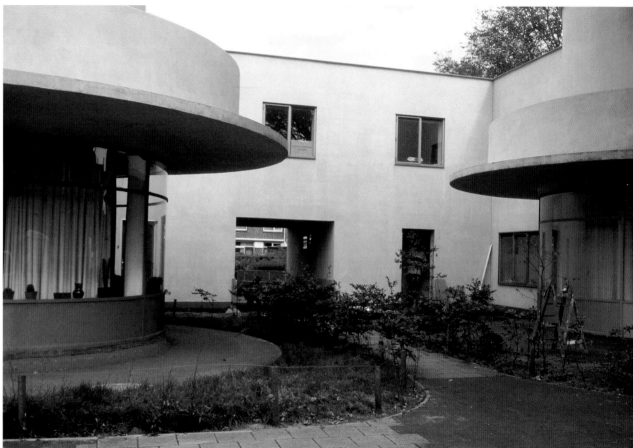

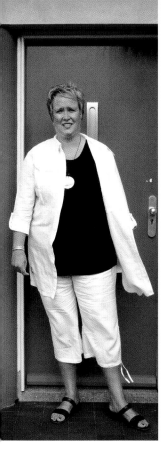

Anja
HOEK VAN HOLLAND, ROTTERDAM, NETHERLANDS, 2004
(BUILDING ARCHITECT: J. J. P. OUD, 1926)

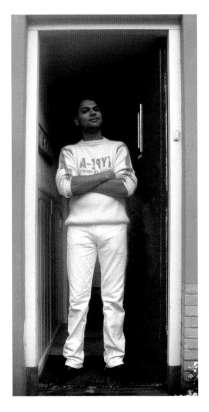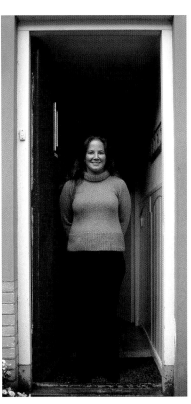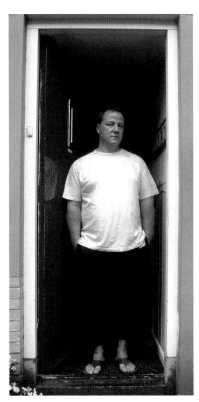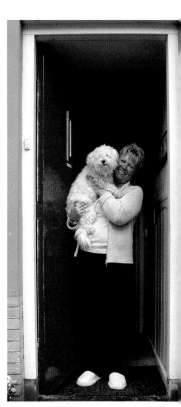

46

Radjinder ("Dino") and Judy,
Frans and Marja
KIEFHOEK, ROTTERDAM, NETHERLANDS, 2004
(BUILDING ARCHITECT: J. J. P. OUD, 1930)

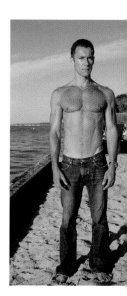

Houseguests
PINES, FIRE ISLAND, 2003

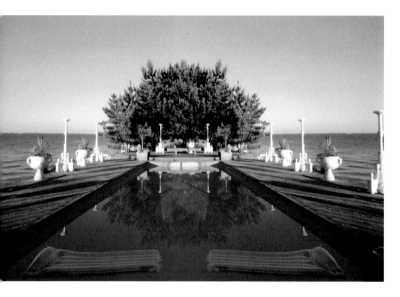 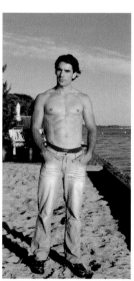 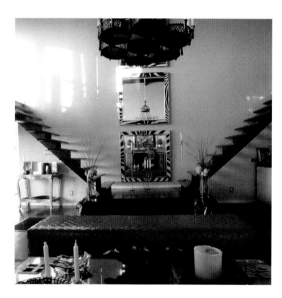 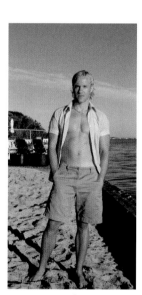

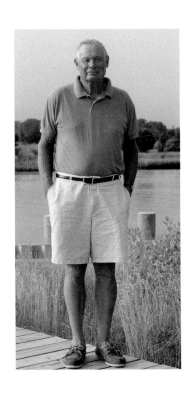
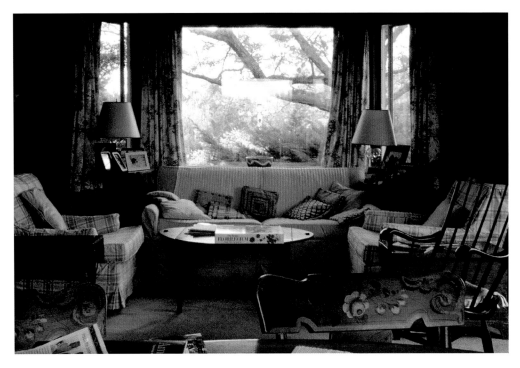
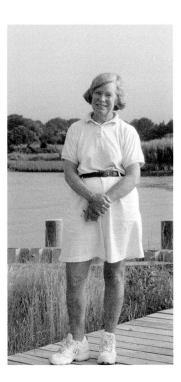

Bob, 72, Joan, 70, 42 years
QUOGUE, NEW YORK, 2003

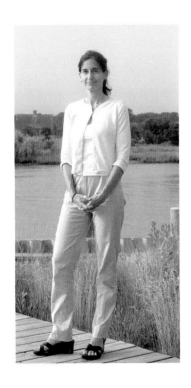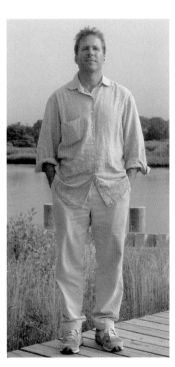

Jeanne, 45, Stuart, 45, 16 years
QUOGUE, NEW YORK, 2003

John, 49, John, 48, 4 years
JAMAICA PLAIN, MASSACHUSETTS, 2002

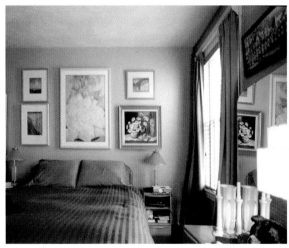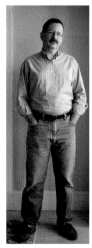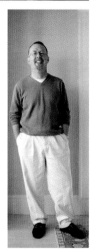

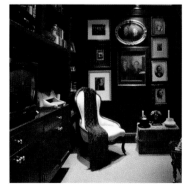

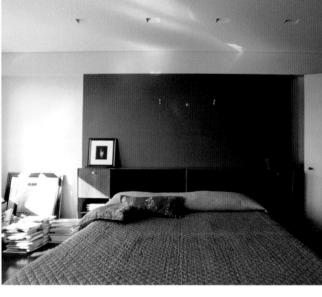
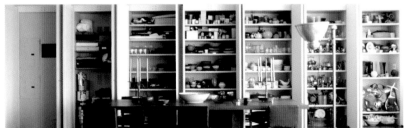
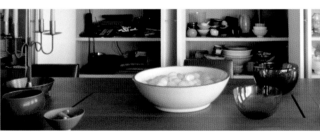

Calvin, 50, Zack, 50, David, 41, 26 years, 16 years
NEW YORK CITY, 2002–3

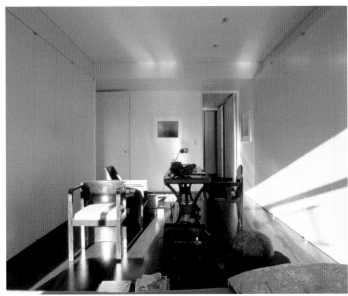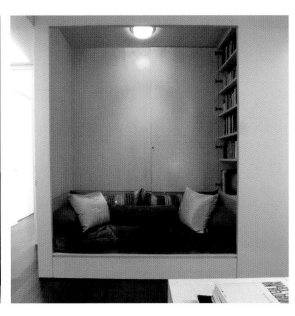

Mark, 49, Steve, 53, 9 years
NASHVILLE, TENNESSEE, 2002

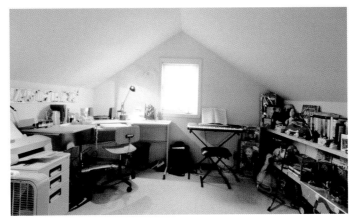

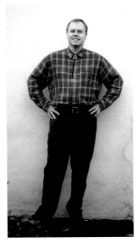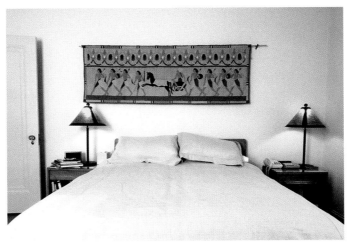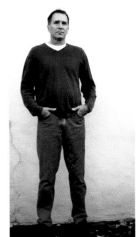

Terry, 48

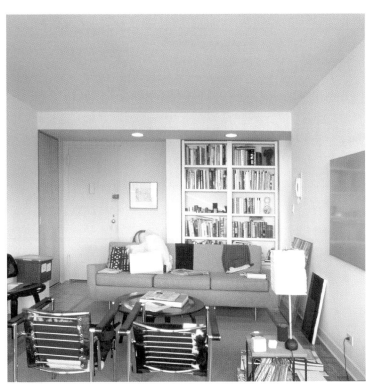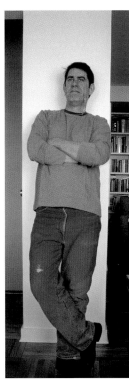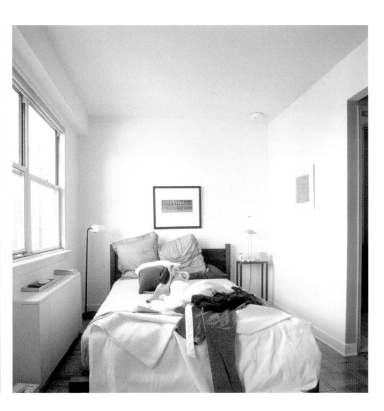

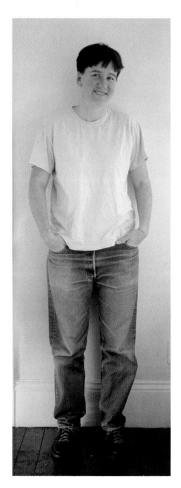

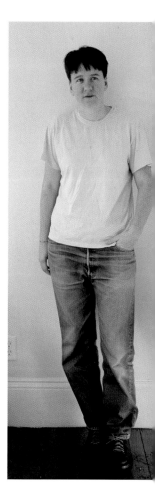

Heather, 32
CAMBRIDGE, MASSACHUSETTS, 2002

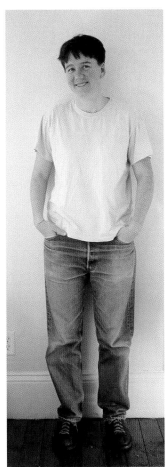

Brian, 35

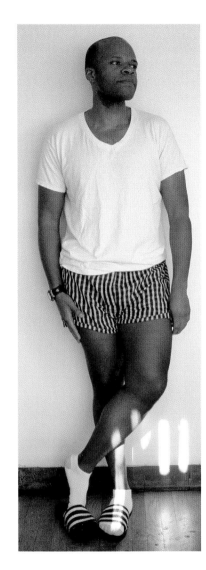

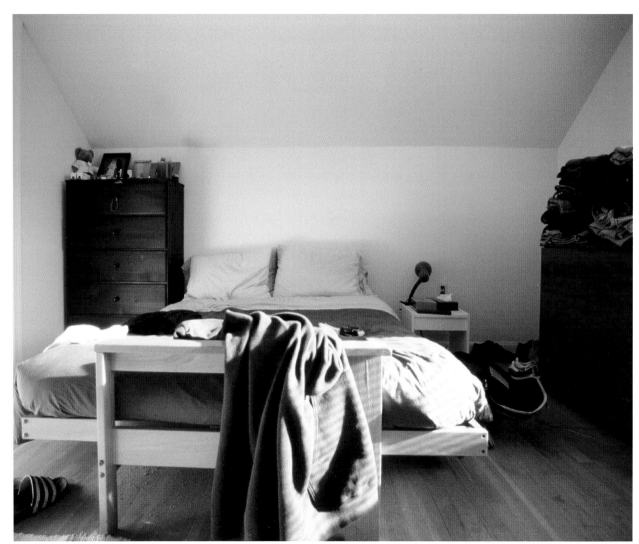

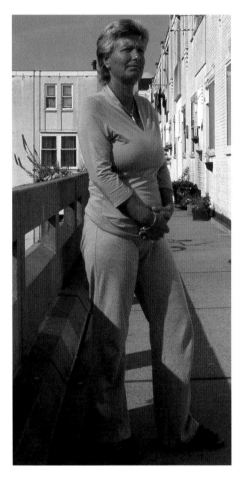 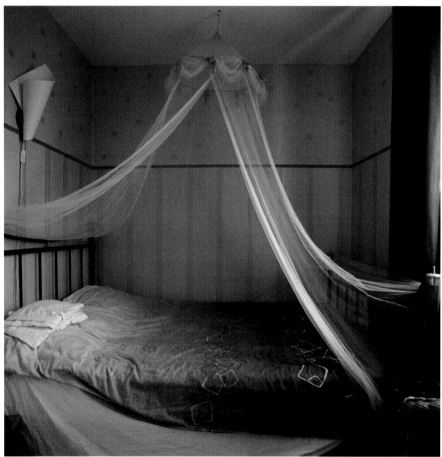

Els
SPANGEN, ROTTERDAM, NETHERLANDS, 2004
(BUILDING ARCHITECT: M. BRINKMAN, 1919–21)

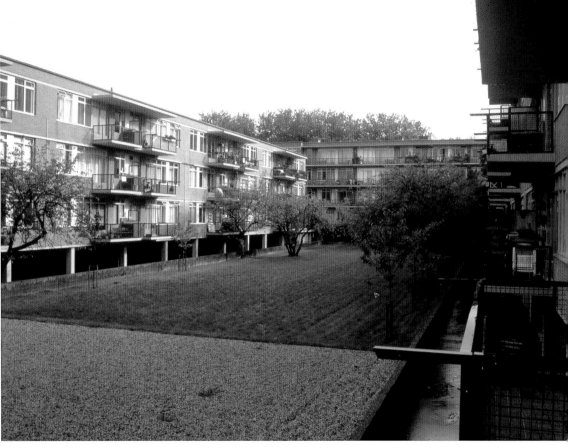

Erwin and Anne, Mees, Kink,
Rotterdam, 2004
(BUILDING ARCHITECT: J. H. VAN DEN BROEK, 1934)

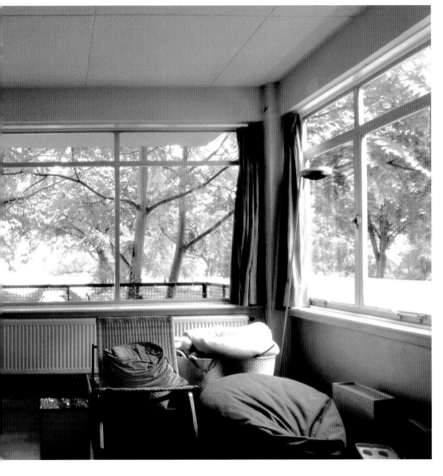

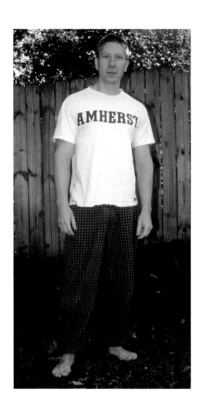

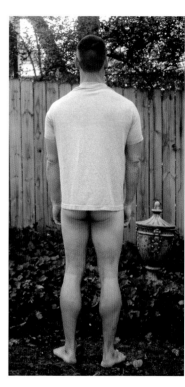

Amherst: Rick, 42, Chuck, 39, 5½ years
ATLANTA, 2003

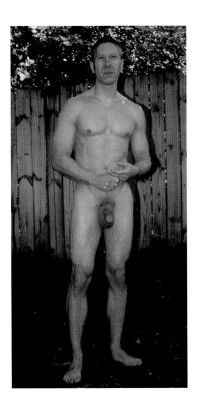

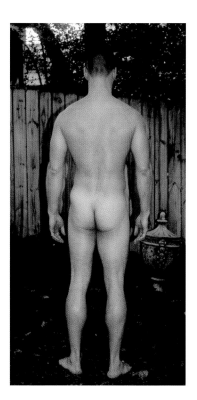

Rick, 42, Chuck, 39, 5½ years
ATLANTA, 2003

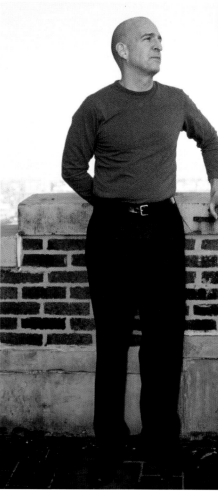

Monty, 51
NEW YORK CITY, 2003

Ali, 43, Michael, 47, 8 years
NEW YORK CITY/FIRE ISLAND, 2002–3

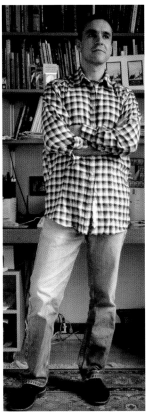
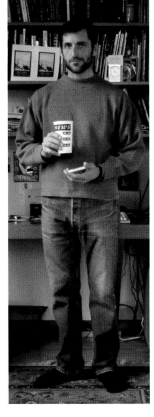

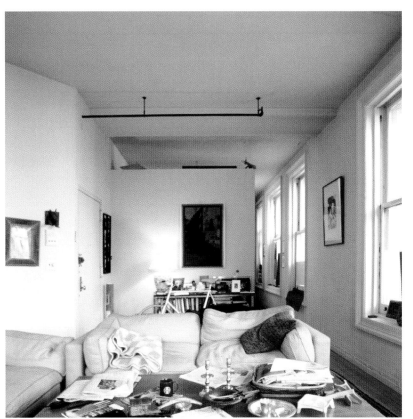

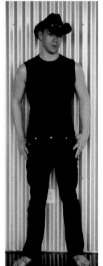
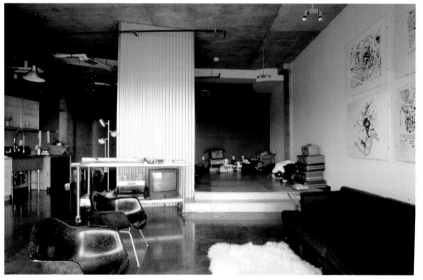
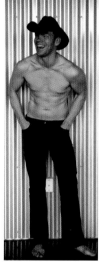

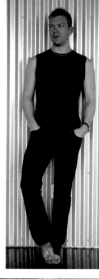
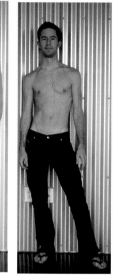

Ryan, 28, Gary, 27

Sven and Joyce
ROTTERDAM, 2004
(BUILDING ARCHITECT: BENTHEM CROUWEL, 2001)

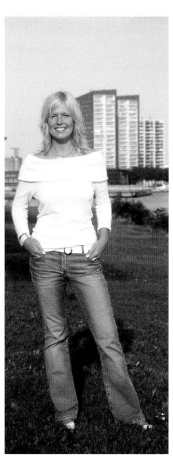

Helen and Agnes
ROTTERDAM, 2004

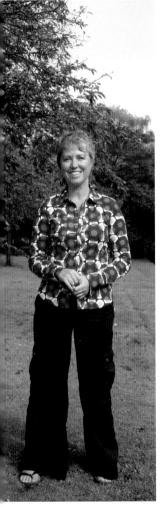
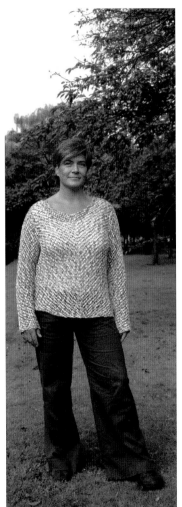

Tom, 42, with Tiger
PINES, FIRE ISLAND, 2003

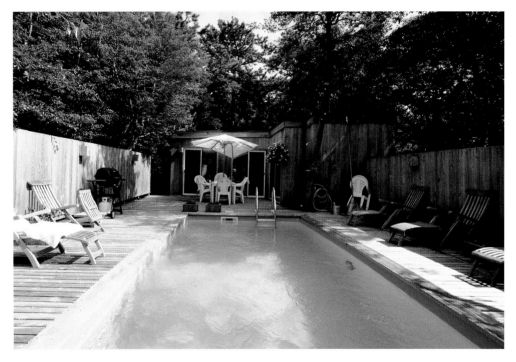

 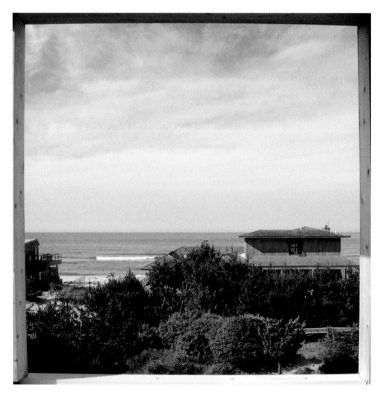

Summer: David, 48
FIRE ISLAND, 2003

 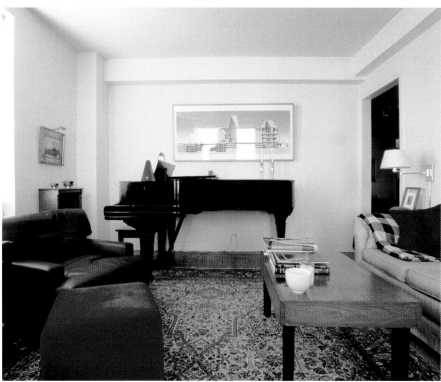 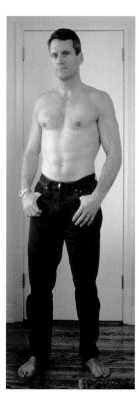

Empire: David, 47
NEW YORK CITY, 2003

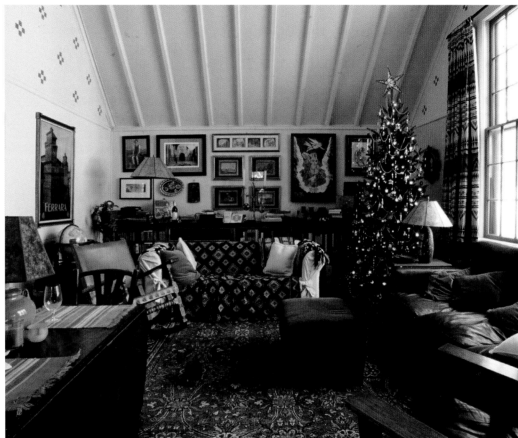

Casey, 55, Gary, 48, 19 years
WOODSTOCK, NEW YORK/NEW YORK CITY, 2002

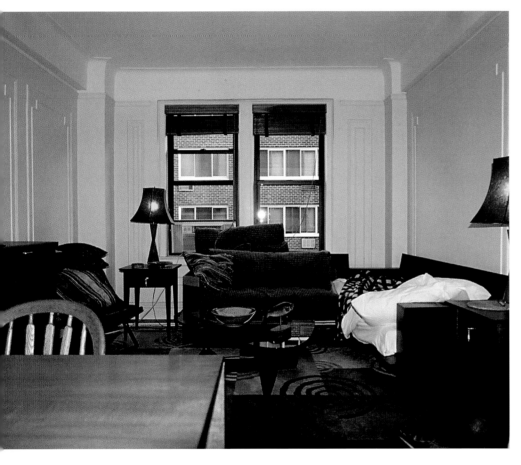

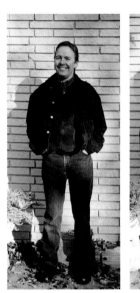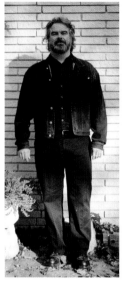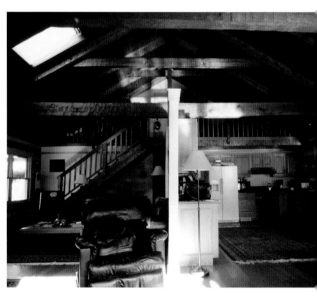

Family Compound: Matthew, 48,
Stephen, 51, 26 years
NASHVILLE, TENNESSEE, 2002

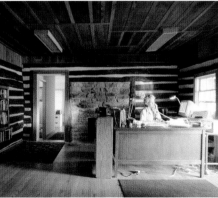

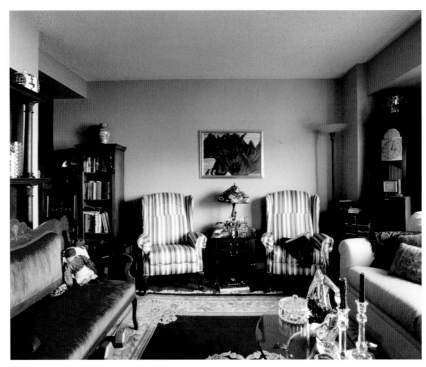

Tony, 41
WASHINGTON, D.C., 2002

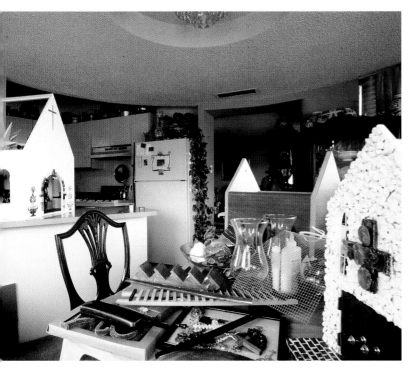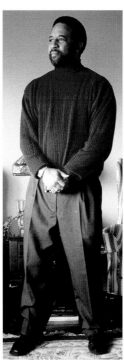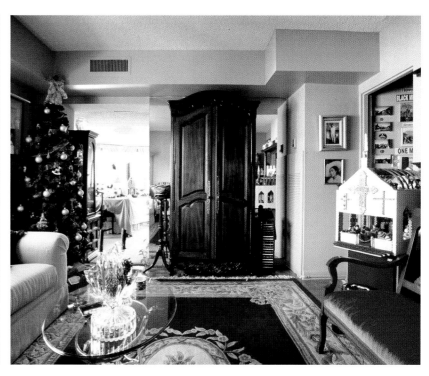

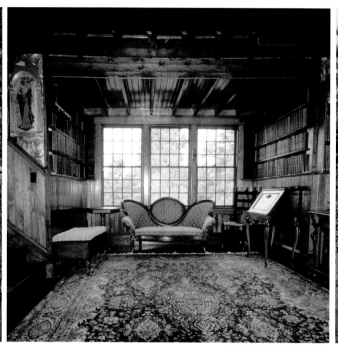
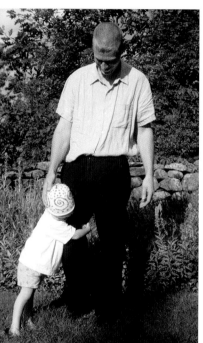

Rebecca, David, and Rowan
HILLCREST, MACDOWELL COLONY, PETERBOROUGH,
NEW HAMPSHIRE, 2003

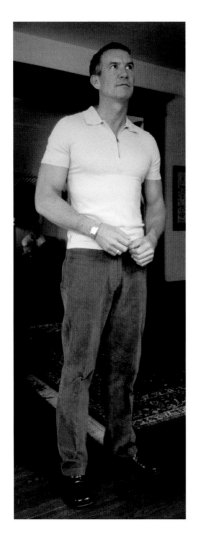

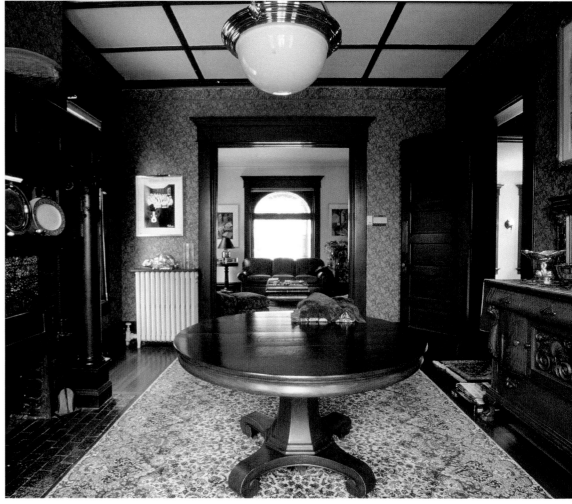

Bruce, 44, Paul, 40, 15 years
COLUMBUS, OHIO, 2002

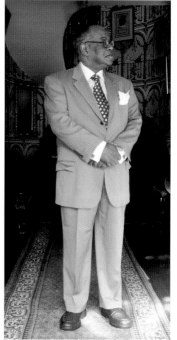

Peter
SPARKS HOUSE, CAMBRIDGE, MASSACHUSETTS, 2003

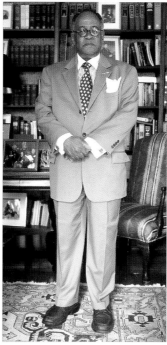
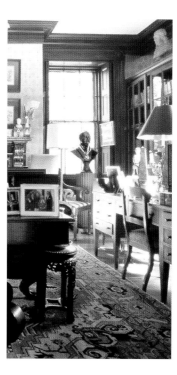

Dale, 54, Elliot, 43
COLUMBUS, OHIO, 2003

 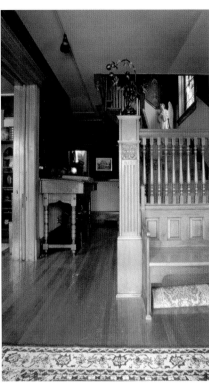 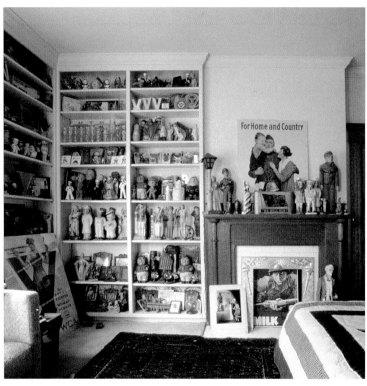

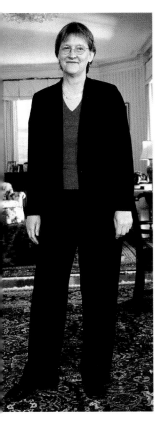

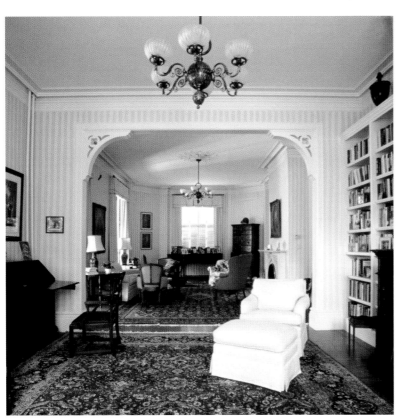

Charles and Drew
GREENLEAF HOUSE, CAMBRIDGE,
MASSACHUSETTS, 2003

Max, 73, Irene, 73, 55 years
PEABODY, MASSACHUSETTS, 2002

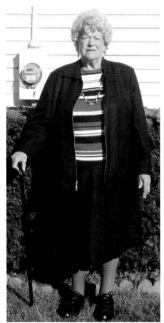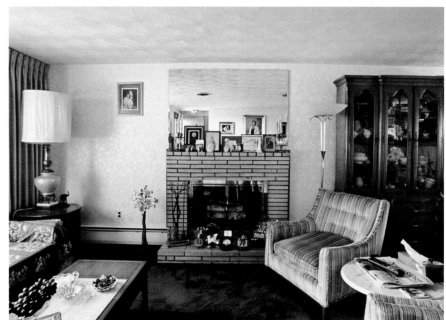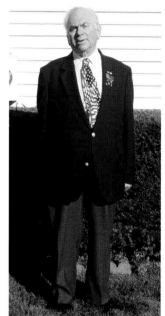

Henk and Con
AMSTERDAM, 2004
(BUILDING ARCHITECT: M. DE KLERK, 1917)

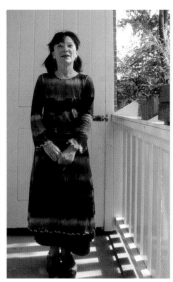

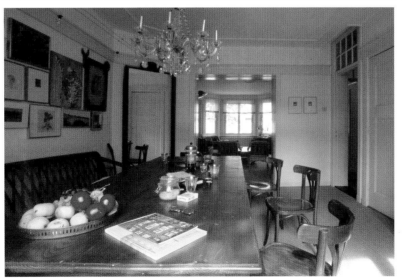

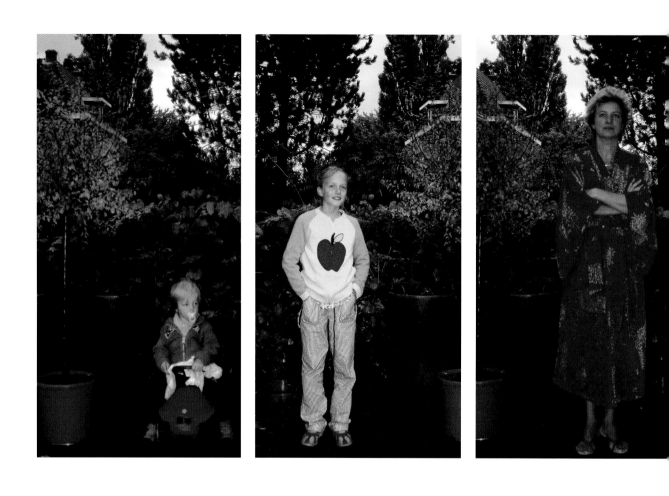

Jacqueline and Adriaan, Ouri, Maria, Lina
ROTTERDAM, 2004

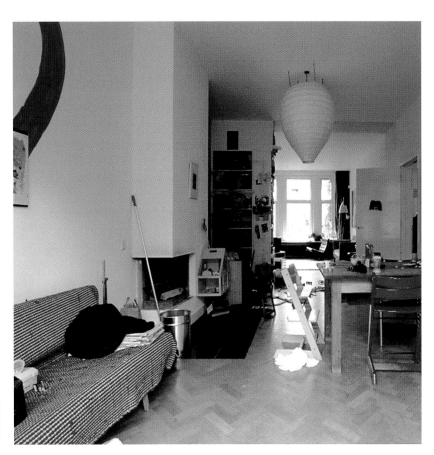
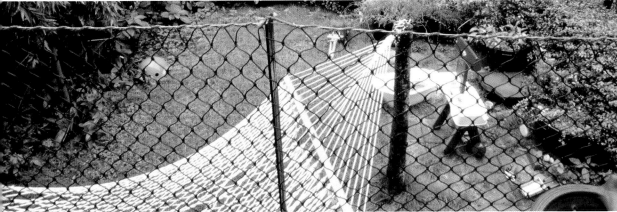

Agymah
MACDOWELL STUDIO, MACDOWELL COLONY, PETERBOROUGH,
NEW HAMPSHIRE, 2003

 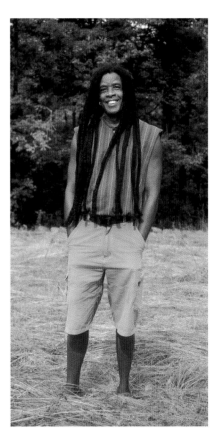

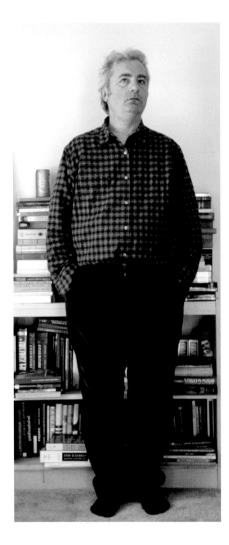
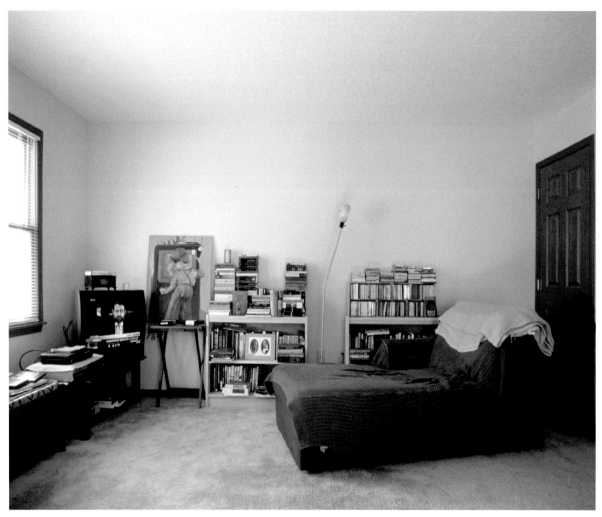

Bill, 51

Andy/Andrew
PROVINCETOWN, MASSACHUSETTS, 2003

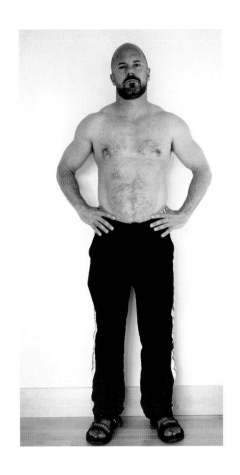

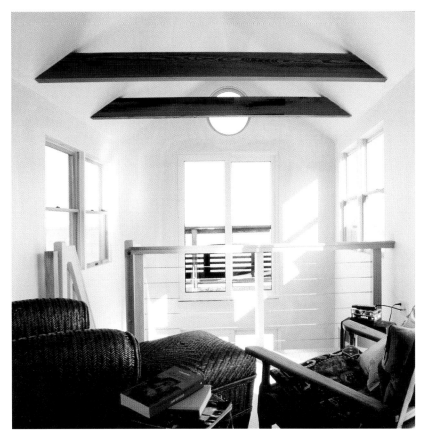

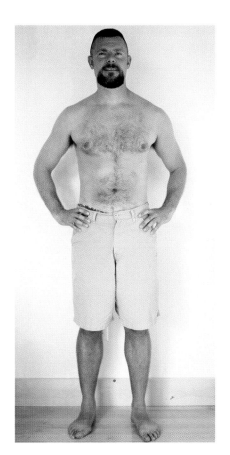

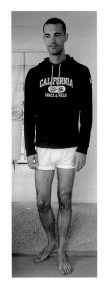 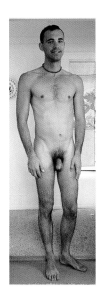 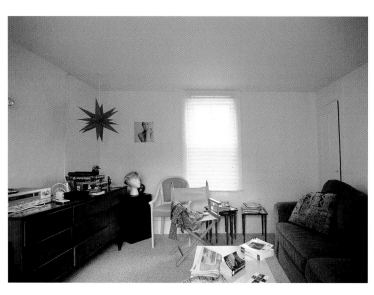 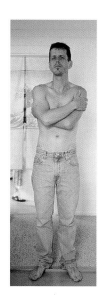 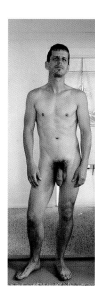

Rodney ("Frankie"), 31
James ("Pepper"), 42, Bruce ("Taffy"), 41, 19 years
Tom ("Cookie"), 39
PROVINCETOWN, MASSACHUSETTS, 2003

112

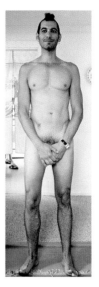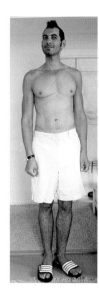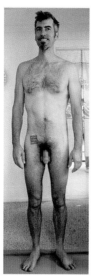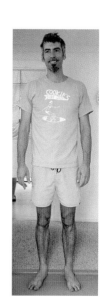

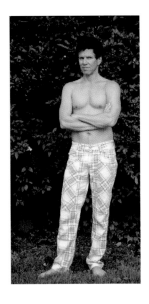 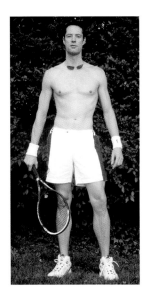

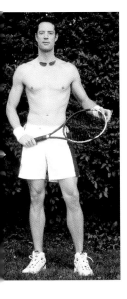 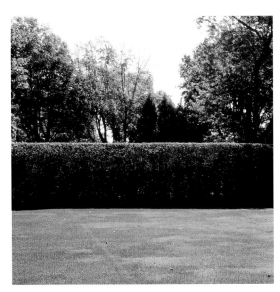 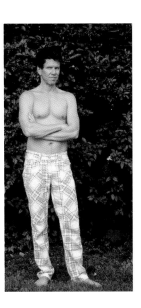

ABA: Jonathan and Christopher
EAST HAMPTON, NEW YORK, 2003

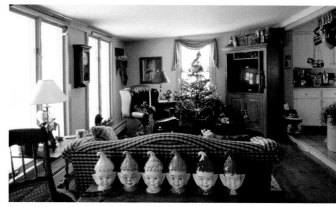

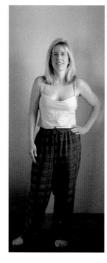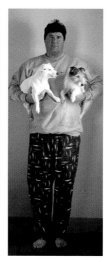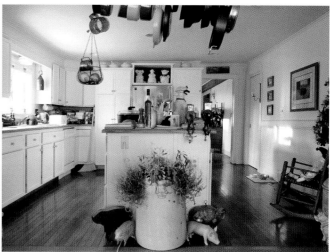

Christmas: Leslie, 35, Doug, 40,
10 years; Micki, 65, Lyman, 68, 38 years; Brett, 34,
Mark, 46, 5 years

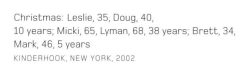

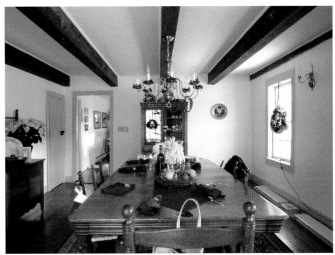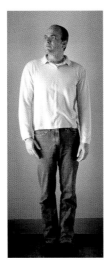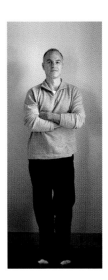

Rosemarie, 31
ALEXANDER STUDIO, MACDOWELL COLONY, PETERBOROUGH,
NEW HAMPSHIRE, 2003

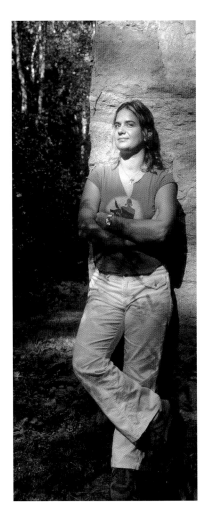

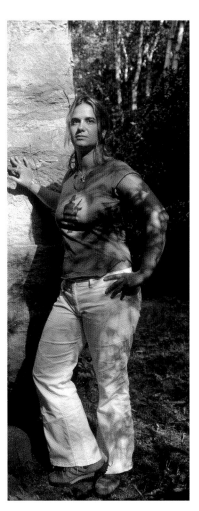

Peter and Aaron
ROTTERDAM, 2004
(BUILDING ARCHITECT: A. KRIJGSMAN, 1954)

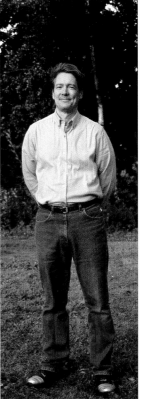
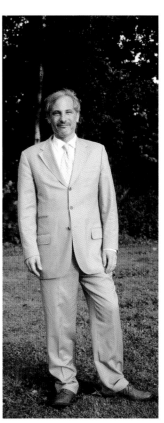

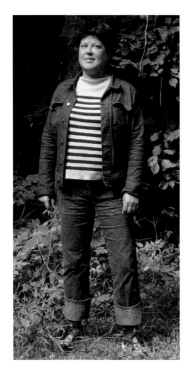 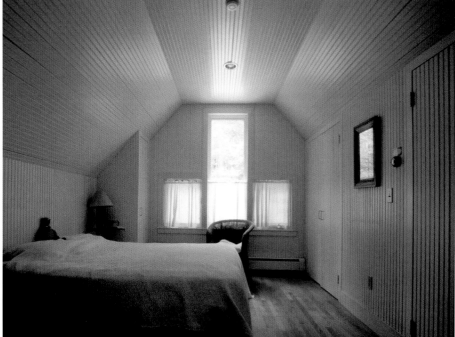 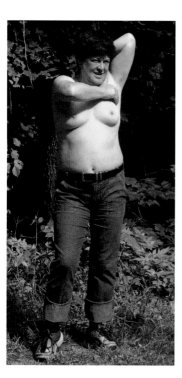

Diane
NEF STUDIO, MACDOWELL COLONY, PETERBOROUGH,
NEW HAMPSHIRE, 2003

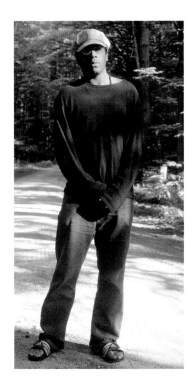

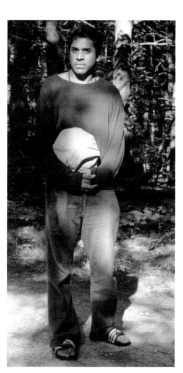

Ravi
STAR STUDIO, MACDOWELL COLONY, PETERBOROUGH,
NEW HAMPSHIRE, 2003

Craft: Lenny, 43, Gary, 48, 3½ years
BOSTON, 2002

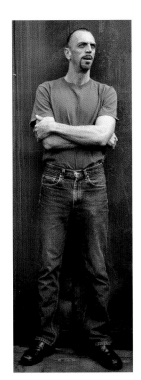
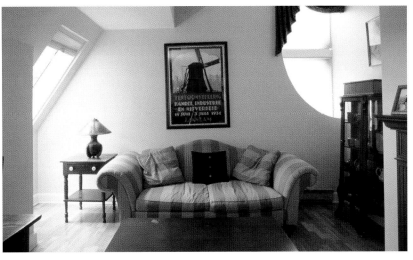

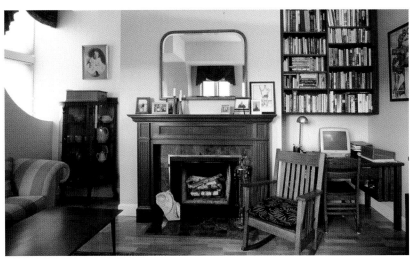

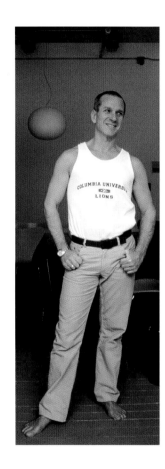
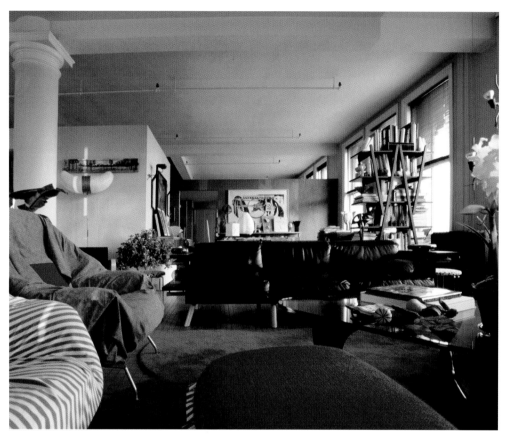
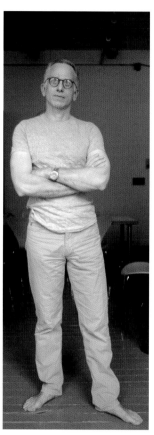

Peter, 53, Paul, 50, 26 years
NEW YORK CITY, 2002

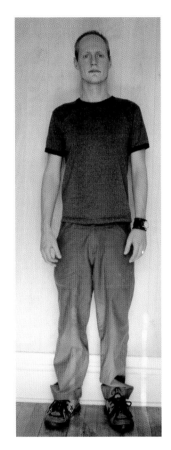
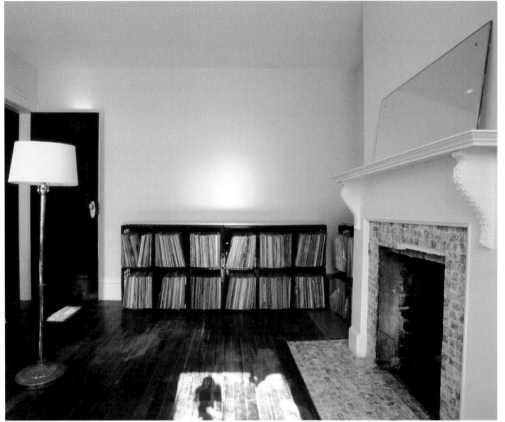
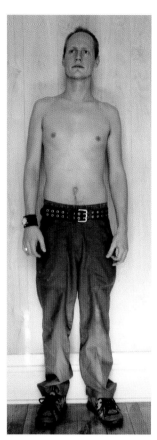

Chris, 33
COLUMBUS, OHIO, 2003

Peter, 48

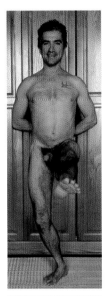

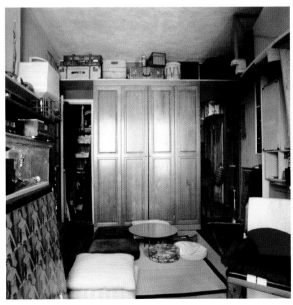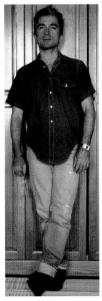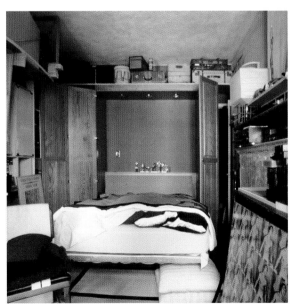

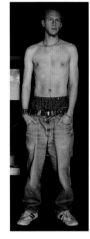 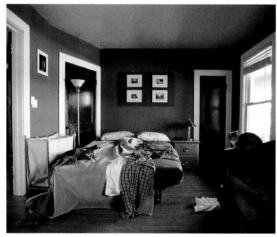 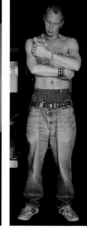 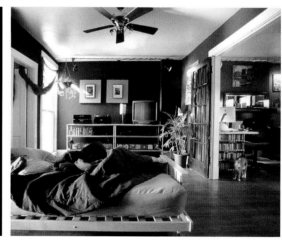 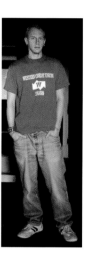

Jason, 29
COLUMBUS, OHIO, 2003

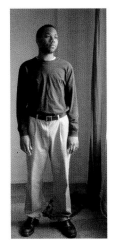 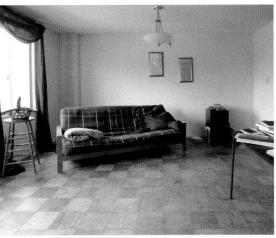 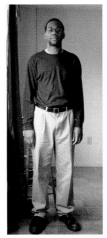 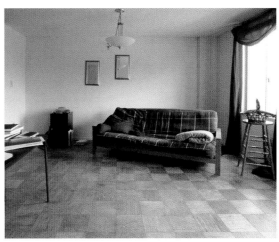 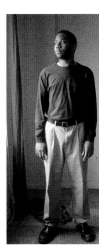

Vincent, 26

TAKOMA PARK, MARYLAND, 2002

Michael, 35
EAST HAMPTON, NEW YORK, 2003

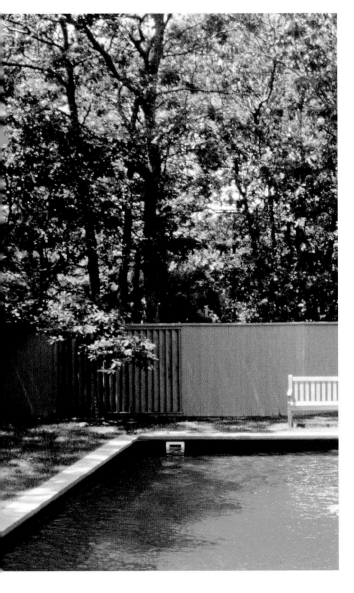
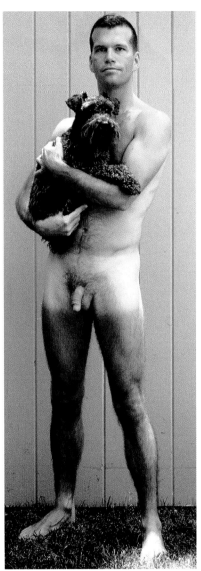
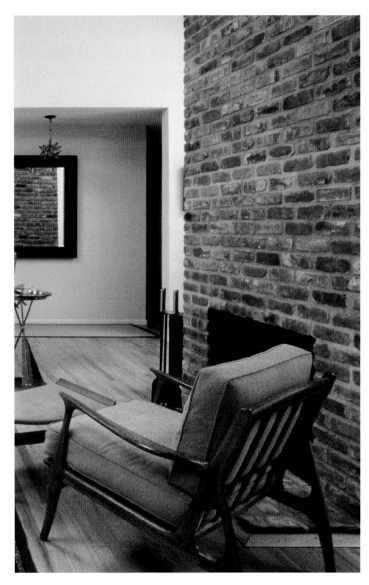

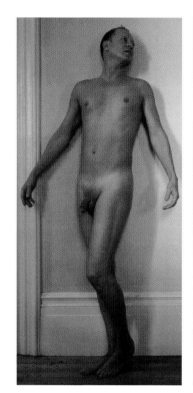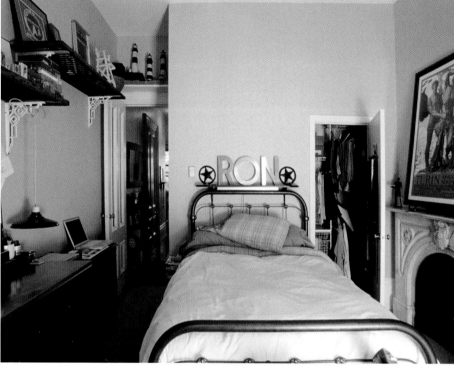

After Viewing Sargent: Ron, 49
BOSTON, 2002

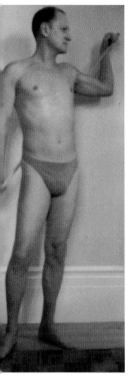
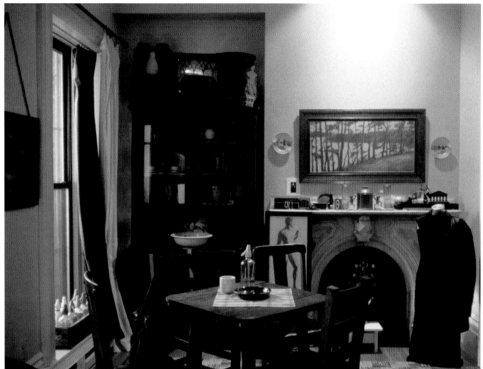
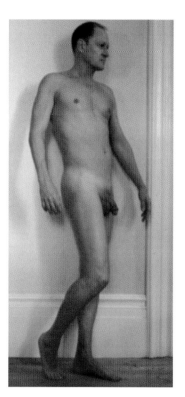

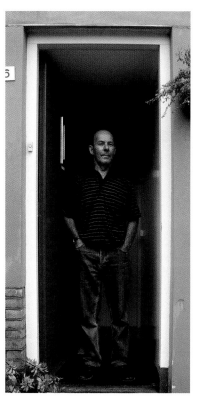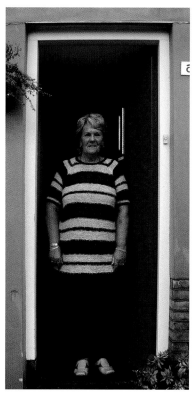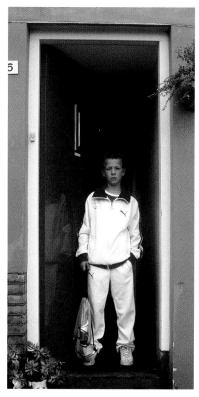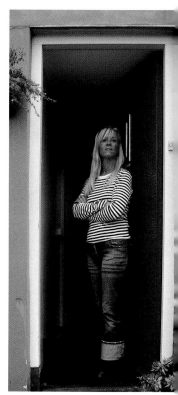
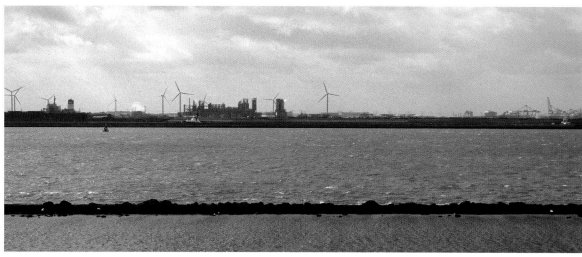

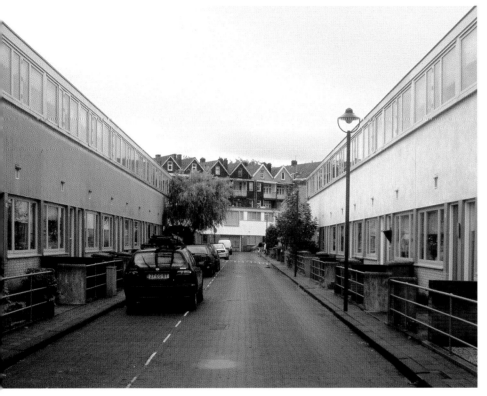

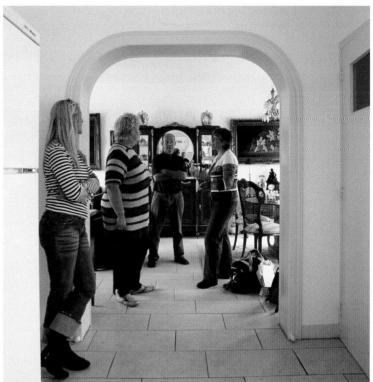

Fam. Terpstra
KIEFHOEK, ROTTERDAM, 2004
(BUILDING ARCHITECT: J. J. P. OUD, 1930)

Thanksgiving: Dad, 82, Mom, 77, 52 years
TORRINGTON, CONNECTICUT, 2002

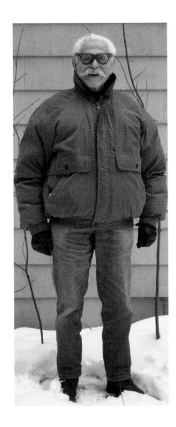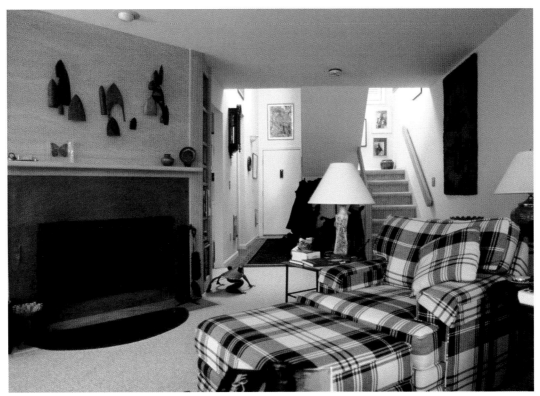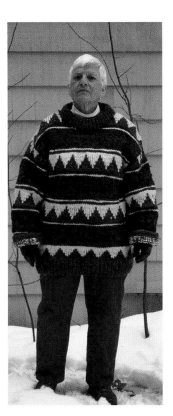

David, 45, Bradley, 44,
5 years

David and Brad are a
stockbroker and a
professor of romance
languages. The photo-
graphs, saturated
blue and yellow, show the
living room of their
modest one-bedroom
apartment, the former

American Philosophy:
Nancy, 42, Mark, 51,
5 years

Nancy is a tenured
professor at a major
eastern university;
her work, some of the

Will, 44

Will is a graphic designer
in Boston. He shares
the small upper floor of
this vacation house
in Provincetown with an
unrelated man. The
screen provides separa-
tion for their spaces.

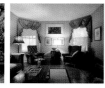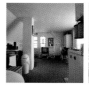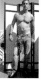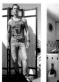

parlor of a townhouse
in Boston's Back Bay,
and the two men at their
front door like a pair
of New England burghers.

most radical writing in
the field, involves
a feminist rereading of
continental philosophy.
She lives with her
two children. Her boy-
friend, Mark, works
in analytic philosophy,
teaches in the same
department, and lives in
a neighboring town.
The sedate domestic
character of the
drapery and furnishings
is striking.

Country: Anthony, 42,
Pierantonio, 41, 17 years
[left]
Anthony, 41, Pierantonio,
40, 16 years [right]

The two men met in
Milan, though Pierantonio
is from Palermo and
Anthony is from New
Jersey. They operate an
art and architecture
publishing house from the
ground floor of their
brownstone. The terrace
of the house, covered
in leaves and overlooking a

Writer: Kevin, 42

A writer of books on
Nijinsky and Beethoven,
Kevin spent a year

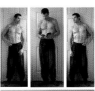

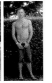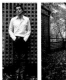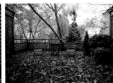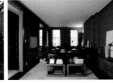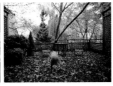

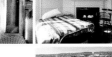

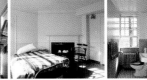

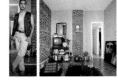

mix of specimen trees,
looks more like Connecti-
cut than Chelsea. In
their traditional summer
house in Amagansett, built
in the late 1990s, their
contemporary art collec-
tion hangs on the walls.

as a Radcliffe fellow and
resident scholar at
Lowell House, one of the
student residences
at Harvard College. The
view of the Charles
is from the tower of that
building. Inside, the
spare institutional bath
room abuts the scholar's
cell with its central
fireplace.

Nikhil, 37

Nikhil is a political
activist in Cambridge.
On occasion, he performs
in Southeast Asian
gay shows in 1960s Bolly-
wood drag.

141

Architect: Paddy

On the outskirts of
Amsterdam, De Archi-
tectengroep converted
the clustered tanks
of an industrial storage
facility into apartments.
Windows and doors
have been cut into the

Radjinder ("Dino") and Judy, Frans and Marja

Truck driver Frans, wife
Marja, daughter Judy,

Three modest houses
separated by privet
hedge sit on a small plot
next to the bridge on
Dune Road in Quogue.
Old photographs of the
site show a little
Japanese teahouse at
the end of the property
across the road—
part of the original
parcel—that faced the

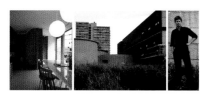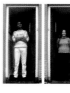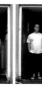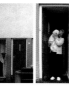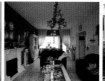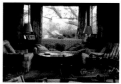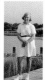

concrete cylinders, and
the units face a common
courtyard with parking.
Paddy, an architect
with the firm, designed
his own one-bedroom
apartment. A saffron
curtain divides the
living room and kitchen
from the sleeping
area. Across the apart-
ment, a bath, with a
translucent wall panel,
draws daylight from the
main room.

and boyfriend Dino share
this house in Kiefhoek.
As in many apartments
in Kiefhoek, units
have been combined and
enlarged from the
original Existenzmini-
mum spaces and
furnished in revival
styles.

ocean. More recent family
photo albums show
hale collegiate groupings
as far back as the 1930s.
In the 1960s, two
sisters occupied two of
the houses with their
husbands and children.
The parents lived in a
smaller house that faced
a shallow dock on the
channel side of the prop-
erty. Now Joan, one
of the sisters, and her
husband, Bob, live in
the smaller house, and
their children and
grandchildren live next
door.

**Jeanne, 45, Stuart, 45,
16 years**

Stuart grew up in New
Jersey with summers
in Quogue. We weathered
architecture school

**Calvin, 50, Zack, 50,
David, 41, 26 years,
16 years**

Calvin and Zack, both
architects, designed this
apartment; David, who
teaches economics (the
Engels/Marx is just
on the nightstand), has
shared the apartment
for sixteen years. The

 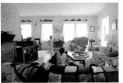 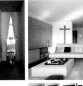 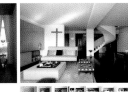 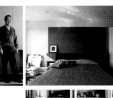 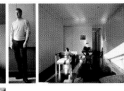 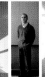 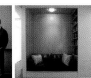

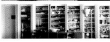

together in the late
1970s. His wife, Jeanne, is
also an architect, and
they have two teenage
girls, Tory and Katie.
The family shared the
summer house in
Quogue with siblings and
their families until
they moved into a little
shingled house on
the other side of the
village.

living room overlooks
the American Museum of
Natural History on
the Upper West Side.
Many of the walls
are floor-to-ceiling
storage—plates
and glass eggs and stag-
claw candlesticks. The
bath at the entry
has a felt panel with a
long slit; the daylight
is soft against the
industrial metal fixtures.

Heather, 32

Heather taught at
Harvard before taking a
position at Penn; she
shared an apartment
with another faculty
member. Their books fill
the living room.

Els

Spangen quarter
housing by M. Brinkman
is a classic example
of the modernist idea
of the elevated
street. Large elevators—
still existing—trans-
ported delivery carts to
wide second-story
walkways. This historic
perimeter block of
social housing is situated

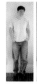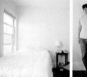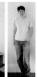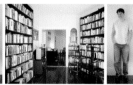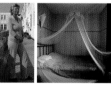

Brian, 35

A doctor who is
researching intercellular
proteins, Brian also
performs in musical
theater on the side. He
lives in a rented
apartment in the attic
of a wood-frame
house near Harvard
Medical School; early
postmodern flourishes
mark the facade.

in a neighborhood
of relatively new
immigrants; the facades
of the contemporary
apartment blocks
are distinguished
by clusters of satellite
dishes.

Ali, 43, Michael, 47, 8 years

Ali is an architect and industrial designer; his partner, Michael, an author, has completed a book on historic American train posters. Every other weekend

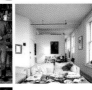

during the summer, they leave their apartment, which is in a converted commercial building on Lower Fifth Avenue, for a vacation house on Fire Island. The house is surrounded by sassafras and has a screened pavilion for dinner parties. The daily *passeggiata* to the little store at the dock—where shirtless men order trussed roasts and tuna steaks from clerks with Long Island accents—provides a break from the beach.

Empire: David, 47

David is a soft-spoken architect with his own office; previously,

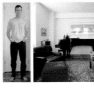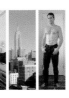

he headed the New York office of an international firm. A Harvard undergrad and grad, he modeled and was on the cover of *Esquire*—an issue on men's fitness—in 1986.

Family Compound: Matthew, 48, Stephen, 51, 26 years

Matthew and Stephen live on an eighty-five-acre compound within the Nashville city limits known as "the family place." One of ten children, Stephen is the head of his family's business in feed and grain and real estate, which is based in a white clapboard farmhouse in the compound, the house where his grand-parents lived. The

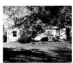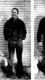

neighboring house, where Stephen grew up— built by his father in the 1930s—has a white plastered interior. During a renovation of the farmhouse, a log cabin dating from 1780 was discovered under the Sheetrock and wallpaper; it now serves as the office. In 1997, Stephen and Matthew, who works with HIV-positive homeless men in the city, built a large two-story log cabin on the property. The double portraits show the couple in front of one of the houses and in front of the stream and the land that are at the center of their life together.

145

Tony, 41

Tony lives in a 1940s residential building in Washington, D.C., where he is a doorman. He has turned the kitchen and dining room of his apartment into a workshop for making little churches complete with stained-glass windows, ministers, and congregants. He started building these

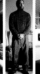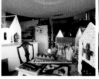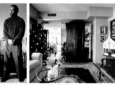

crèchelike structures after his grand-mother died, using her disassembled costume jewelry. In the hall outside the bedroom are framed memorabilia from Freedom Marches and pictures of Malcolm X.

Bruce, 44, Paul, 40, 15 years

My realtor, Bruce, and his architect partner, Paul, live on one of the grand-est intact Victorian

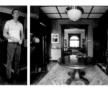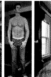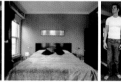

streets in Columbus. The couple is prominent in business, neighborhood, and gay communities; they host two sought-after annual parties, one at Christmas and the other during the summer around their pool. The familial decor of the living room contrasts with the leopard-patterned bedspread in Bruce's bedroom.

Rebecca, David, and Rowan

MacDowell Colony resident director David lived with his wife, Rebecca, and their daughter, Rowan, in Hill-crest, originally the home of colony founders Edward and Marian MacDowell. Recently, the family has

moved to a sweet house just down the road— a home of their own after many years in the director's residence. The original farmhouse will be used for guests.

Max, 73, Irene, 73, 55 years

My aunt and uncle's house was built in 1962. Ceilings are screed plaster; they sparkle in the light of the starburst bulbs in the dining room chandelier. The rooms are painted in primary colors: the kitchen is yellow, the living room blue, and the bedroom pink with red curtains. The living room is my aunt's domain; it remains

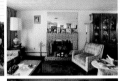

essentially untouched, the room I remember from my childhood, with one glass bowl of plastic grapes and another of wrapped hard candies. The basement—the former bar and rec room where we played Allan Sherman records—has become my uncle's realm, overtaken by stacks of paper and stuffed animals from his volunteer work with children at the Boston Shriners Hospital. Pictures of long-gone family members hang in frames on the walls.

Jacqueline and Adriaan, Ouri, Maria, Lina

Adriaan, a vibrant landscape architect working in the Netherlands and abroad, is married to Jacqueline, a well-known stage actress. The family lives in a

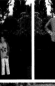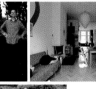

Victorian-era brick row house; the back porch overlooks a hammock. The children were getting ready for school; little Ouri, atop his red toy truck, had a bit of a cold.

Agymah

A poet from New York, Agymah now lives and teaches in Oklahoma. MacDowell "tombstones," simple wooden panels that record the names of artists who have been in residence since the first quarter of the 1900s, hang on the back wall.

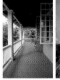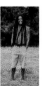

147

Rodney ("Frankie"), 31
James ("Pepper"), 42,
Bruce ("Taffy"), 41,
19 years
Tom ("Cookie"), 39

A group of men from
Boston have rented this
house in "Ptown" for
a number of years. In the
attic, Christmas
lights are strung above
multiple beds.

ABA: Jonathan and
Christopher

A composer who is also
the founding director
and conductor of an
orchestra dedicated to
new music and his

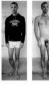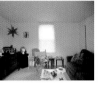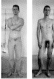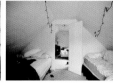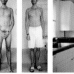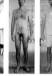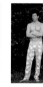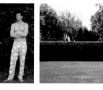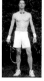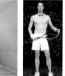

cardiologist partner
spend parts of the
summer at this house.
There are various
outbuildings on the
property; one has been
converted to a small gym
and another, an old
barn, to a music studio.
The tennis courts,
set in a lower parterre,
are not visible from
the pool or main house.
The tall privet hedge,
a consistent character-
istic of this community,
creates a green
wall between street and
private lawn.

Craft: Lenny, 43, Gary, 48, 3½ years

A graphic designer for television and a window dresser for a chain of fabric stores, Lenny and Gary lived in a former church. The building was one of the first residential conversions in Boston's now gentrified South End. The Arts and Crafts–style interior

Peter and Aaron

Artist Peter and museum director Aaron, both transplanted Americans, live in what was formerly a municipal building on the outskirts of Rotterdam. The structure sits in the middle of a

Diane

A founder of Drag Kings, Diane as odalisque stands opposite her puckish clothed self.

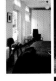

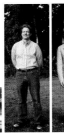
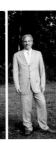
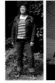

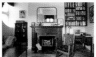

public park with large trees. On the lower floor is a studio; the library and study on the second level look into the treetops.

was the decor of choice for these leather boys. Gary showed me his Halloween costume for an upcoming party in Provincetown. The peek-aboo chaps are Ultrasuede; the codpiece, not without tongue in cheek, was trimmed from an old pair of Levis. The couple recently bought a house in a newly gay suburb of Boston.

Peter, 48

Peter started at Notre Dame as a premed student but turned to ceramics and then became a modern dancer. In the early 1980s, he performed with Dance Theater Workshop in New York and appeared in the downtown performing art scene. Later 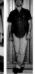 in his career, after two years of touring with Les Ballets Trocadero de Monte Carlo (the Trocks), he began to provide video documentation for a variety of dance companies. Peter has lived in this studio apartment of roughly 250 square feet on Jane Street since 1990; he built the Murphy bed, which folds down over the dining/coffee table and tatami mat in the living room, and made the Warhol film collage, which covers part of his work space. The apartment is also an editing studio.

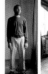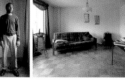

Vincent, 26

Vincent is a graduate student at the University of Maryland. His dissertation addresses the music industry and cultural identity. Vincent's apartment is bare except for stacks of Sarah Vaughan albums in the living room.

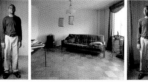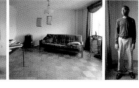

After Viewing Sargent: Ron, 49

Ron is a nurse living in the Back Bay area of Boston. In his apartment is a book of drawings of male figures by John Singer Sargent. He said he "lived with these people" and had always wanted to be one of them.

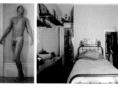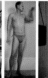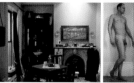

Thanksgiving: Dad, 82,
Mom, 77, 52 years

My parents bought this
condominium as a
weekend place in 1990.

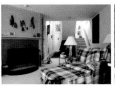

The decor—tile
accents in the kitchen,
contrasting wallpaper,
bold fabric patterns—
reflects my mother's
training in interior
design in the 1960s.
The metal wall hanging
and the hooked rug
(with letters copied from
the Rubaiyat of Omar
Khayyam) are also
her creations. The pots
and the lamp bases
are my father's, from
the years of Saturdays
he spent at a potter's
wheel at the Craft
Students League.

MARK ROBBINS is dean of the School of Architecture at Syracuse University. Previously, he was director of design at the National Endowment for the Arts in Washington, D.C., curator of architecture at the Wexner Center for the Arts in Columbus, Ohio, and associate professor at the Knowlton School of Architecture at Ohio State University. He has also taught at the University of Virginia, SCI-Arc, and the Graduate School of Design at Harvard.

Robbins has received the Rome Prize from the American Academy in Rome and grants from the National Endowment for the Arts, the Graham Foundation, and the State Arts Councils of Ohio and New York. He has received fellowships from the Radcliffe Institute for Advanced Study at Harvard University and the New York Foundation for the Arts and residencies at the MacDowell Colony, the Ragdale Foundation, and the Chicago Institute for Architecture and Urbanism.

JULIE LASKY is editor-in-chief of *I.D.*, the award-winning magazine of international design. Prior to that, she was editor-in-chief of *Interiors* magazine. A widely published writer and critic, she has contributed to the *New York Times, Metropolis, Dwell, Architecture, Slate, Surface, The National Scholar*, and NPR, and she is the author of two books: *Borrowed Design: Use and Abuse of Historical Form* (with Steven Heller) and *Some People Can't Surf: The Graphic Design of Art Chantry*.

BILL HORRIGAN has been director of the Media Arts Program at the Wexner Center for the Arts in Columbus, Ohio, since its opening in 1989. He has developed projects with Chris Marker, Johan van der Keuken, Mark Dion, Todd Haynes and Christine Vachon, Julia Scher, and Bruce and Norman Yonemoto, among others.